THE GOLDEN HAT

Talking Back to Autism

Kate Winslet with Keli Thorsteinsson and Margret Ericsdottir

Simon & Schuster
New York London Toronto Sydney New Delhi

Simon & Schuster
1230 Avenue of the Americas
New York, New York 10020

First Simon & Schuster hardcover edition March 2012

SIMON & SCHUSTER and colophon are registered trademarks of Simon & Schuster, Inc.

For information about special discounts for bulk purchases, please contact Simon & Schuster Special Sales at 1-866-506-1949 or business@simonandschuster.com.

The Simon & Schuster Speakers Bureau can bring authors to your live event. For more information or to book an event contact the Simon & Schuster Speakers Bureau at 1-866-248-3049 or visit our website at www.simonspeakers.com.

Designed by Emma Leslie & Vanessa O'Reilly

Manufactured in the United States of America

10 9 8 7 6 5 4 3 2 1

Library of Congress Cataloging-in-Publication Data
Winslet, Kate.
 The golden hat : talking back to autism / Kate Winslet ; with Keli Thorsteinsson and Margret
Ericsdottir.—1st Simon & Schuster hardcover ed.
 p. cm.
 1. Autism in children. 2. Children with disabilities—Means of communication. 3. Celebrities—
Quotations. I. Thorsteinsson, Keli. II. Ericsdottir, Margret Dagmar. III. Title.
 RJ506.A9W535 2012
 618.92'85882—dc23
 2011042459

ISBN 978-1-4516-4543-9
ISBN 978-1-4516-4545-3 (ebook)

Editors: Emma Leslie and Lisa Helt
Cover photo: Mario Testino
Layout Editors: Vanessa O'Reilly and Tasmin Coleman
Production: Carrie Lukasiewicz and Lisa Helt

CONTENTS

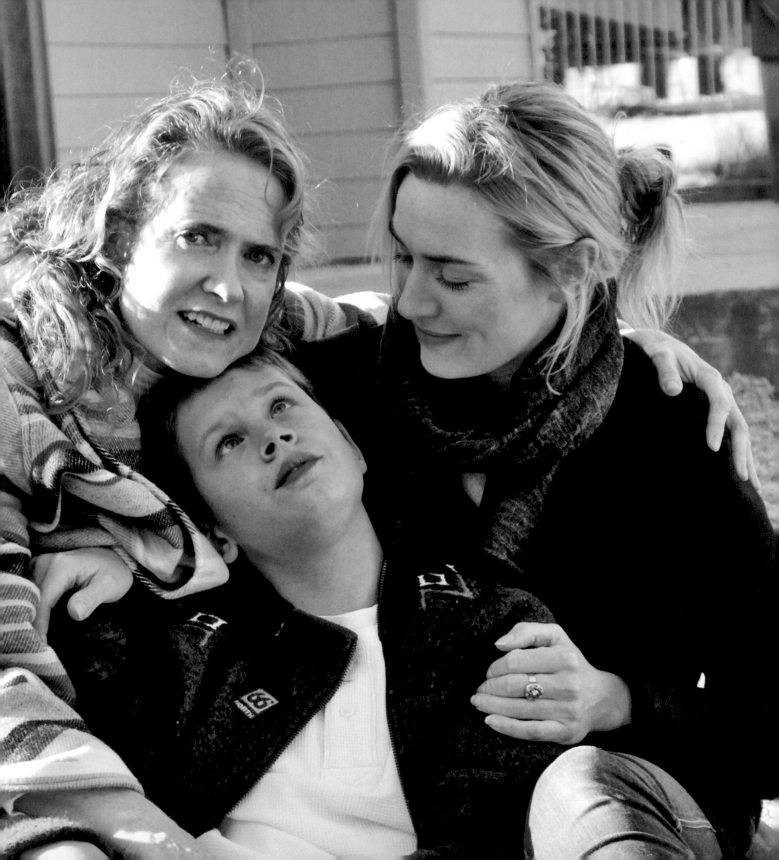

THE GOLDEN HAT

THIS BOY HAD A GOLDEN HAT.

THE HAT WAS MAGICAL. IT COULD TALK.

THE BOY DID NOT HAVE ANY VOICE. HE HAD AUTISM.

HIS HAT WAS ALWAYS WITH HIM.

HIS HAT WAS LOST ONE DAY.

NOW HE HAD NO WAY OF TELLING THEM HIS STORIES.

HIS MOM AND DAD BECAME SAD.

THEY TAUGHT HIM SPELLING ON A LETTERBOARD.

IT WAS HARD.

END.

Photo: Margret, Keli, and Kate. Austin, Texas, 2010.
Poem by Keli Thorsteinsson.

" I simply couldn't conceive of how devastating it would be not to be able to hear my children's voices. Not to be able to communicate with one's children, to hear them learn, grow, and express themselves verbally. "

KATE WINSLET

From: Kate Winslet
Subject: Re: Keli poems
Date: September 11, 2009 4:14:54 PM CDT
To: Margret D. Ericsdottir

Hi Margret,

I hope you've had a good week down in Austin!!!!

I wanted to let you know that I have come up with an idea
to raise money for Autism.
I will tell you all the details at another time, but I'm
trying to secure some sponsorship to get this started.
What is the name of the charity that you would like money
donated to?
Have you set up something in Keli's name?
Would you like to?

Let me know.

I'm so excited about this idea. It just came into my head
when I was brushing my teeth last night. It involves a
hat, and a lot of very famous people!

All inspired by Keli.

Xxxxxxxxx
Love kate. Xxx

KATE'S STORY

So that's how this started, I was cleaning my teeth one evening, in the quiet of my apartment, the kids were in bed, and I was thinking about Margret and Keli.

I had met them a few months earlier when I had provided the English-language narration for their film *A Mother's Courage* (aka *The Sunshine Boy*). Margret is the mother of Keli, who is a teenager with nonverbal autism. She had made the film herself, in the hope that it would illuminate Keli's situation and the lack of help and resources available to them as a family with a nonverbal son. The film had taken her on an incredible journey, which resulted in Keli finally finding a way to communicate with his loved ones for the first time in ten years. It moved me beyond all expectation, and so there I found myself thinking about them again that evening.

I first watched the film with my daughter Mia, who was eight at the time. At the end, she turned to me and said, "Mum, can you imagine what it would be like if I couldn't tell you that I love you?"

I simply couldn't conceive of how devastating it would be not to be able to hear my children's voices. Not to be able to communicate with them, to hear them learn, grow, and express themselves verbally. How fortunate, how blessed I am. This overwhelmed me. I can talk to my children, I can respond to their needs and comfort them when they tell me they are unwell. I can tell them stories and hear them tell theirs. We can converse, share, sing, and laugh.

Through working on the film, I entered a new world of families with children who have autism, where the challenges they face daily are profound and overwhelming. The look on Keli's face when he typed his first words to me touched me as a mother, and as a human being. I witnessed Margret discover her son after years of silence. As a mother of two very verbal, expressive, affectionate children, it wasn't enough to provide this narration alone and to simply walk away.

Margret and I kept in close contact. She would send me Keli's writing and poems, which moved me to tears on so many occasions.

One poem was *The Golden Hat*.

The Golden Hat

This boy had a golden hat.
The hat was magical. It could talk.
The boy did not have any voice. He had autism.
His hat was always with him.
His hat was lost one day.
Now he had no way of telling them his stories.
His mom and dad became sad.
They taught him spelling on a letterboard.
It was hard.
End.

So I came up with this idea . . . to send my favourite beaten-up trilby to as many well-known people as I could track down and ask them to photograph themselves wearing it! I would then make a book of the self-portraits, alongside Keli's writings and Margret's story.

Amazingly, nearly every single person I asked said yes! Leo DiCaprio, Angelina Jolie, Johnny Depp, Richard Branson, Meryl Streep, Steven Spielberg, James Cameron, Tom Hanks, Jodie Foster, Julia Roberts, Natalie Portman . . . the list just went on and on. It was heart-warming to discover just how willing people were to help, and it was an amazing feeling to be able to instigate that warmth and generosity in people.

The instructions were simple:
Put the hat on. Take a self-portrait.
"Think about the fact that many individuals with nonverbal autism have never been able to communicate. Now express something that's important to you; this quote will be included in the book."

The very intimate self-portraits and quotes are featured alongside the photographs and quotes of ten individuals with autism. These extremely moving pages illustrate and celebrate some of their first communications—that gigantic leap forward into a world where their potential can finally be realised and their desires expressed. No one is going to tell you that the most you can hope to achieve is being able to tie your laces, when, like Carly Fleischmann, your first words are "Teeth—Hurt—Help."

These individuals, with support and assistance, have the capacity to understand the world around them and assess their own needs on a practical level as well as to understand more complex and profound concepts. For example, when Neal Katz started to communicate, he said, "Mom, I'd like to put you on the spot. You need to be more of a listener," and Josh Andrus was twenty when he was able to communicate this to his parents: "Try to fully understand my condition, because I get so lonely."

It seems that the world is still struggling to know where to place people with nonverbal autism. Often institutionalised and never able to experience what it feels like to be a part of society, it's so hard to find a sense of community and support. So rarely are these individuals encouraged or fortunate enough to find the right environment in which they can receive the correct education and learn how to communicate.

This book celebrates self-expression through self-portraiture, which is a rare representation of many of the celebrities featured in the book, through the many quotes, and through Keli's poetry, and Margret's story. My hope for the book is that it helps people to realise the potential that lies within the minds of individuals with nonverbal autism. There are approximately 67 million people worldwide with autism, around 50 percent of whom do not have functional speech. With this book we have shown that there are ways to hear those individuals. We need to start listening.

The proceeds from this book will go to the Golden Hat Foundation, a charity set up by Margret and myself. Our aim is to improve awareness about the capabilities of people living with autism. And we have a long-term mission, which is to provide assisted-living campuses for people with severe autism, where they will receive specific educational direction, job training, and, very importantly, a community and environment within which to thrive, where their individual strengths as well as needs can be taken into account. We hope that these campuses will serve as models to demonstrate the intellectual capabilities of people with autism, and in doing so, encourage society to realise the benefits of including these individuals, and ultimately learn from them.

KATE WINSLET

This is what the Golden Hat Foundation is all about, giving voices to those without. With your generosity and support, we can change the world for people with autism. I truly believe this is their time to GLOW

Kate Winslet x

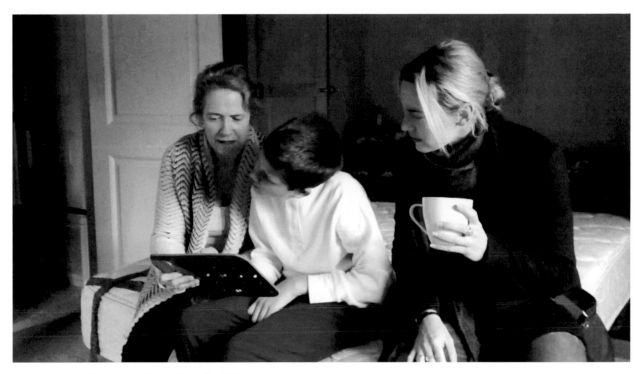

Margret, Keli, and Kate, Austin, Texas, November 2010.

" Everything is as it is supposed to be, except one thing. Your senses are all mixed up. You cannot see and hear at the same time. You only get a fragmented view of your environment. You have little sense of where your body is. You cannot speak. You have no voice. "

MARGRET D. ERICSDOTTIR

MARGRET'S STORY

Imagine waking up in your bed, just as you are now, with all your mental capacity and intelligence. In your mind, you know that everything is the way it is supposed to be. The bedside table is where it has always been, with the book you're reading and your iPhone. The closet hasn't moved. The window is half open, and the sun shines through the trees into your bedroom. Everything is as it is supposed to be, except one thing. Your senses are all mixed up. You cannot see and hear at the same time. You only get a fragmented view of your environment. You have little sense of where your body is. You cannot speak. You have no voice.

We take the simplest things for granted. We rarely stop to count our blessings. The ability to express our feelings, desires, and needs is one of the things we very rarely reflect upon. Nevertheless, the truth of the matter is: We're lucky. I am reminded of my luck every day. My son, Keli, is a wonderful thirteen year-old boy. He is a beautiful, vibrant boy who shines with happiness. On the surface, he appears to live in his own little world, apart from his surroundings, when in fact he is right there with us, paying attention to everything.

Keli has many interests. His passion for music is great—not just one type of music, but everything from Beethoven to the Beatles. He loves watching piano concerts, and he really wants to play the piano himself, even though it is not easy for him. He immerses himself in every kind of literature. He loves swimming, going bowling, and watching movies. In short, Keli is a very typical thirteen-year-old boy, with hopes and dreams like the rest of us. But my lovely boy has severe autism. I am not even sure if he sees and hears at the same time. He is completely nonverbal, which means that he cannot express himself in the same way as you and I. He has very limited body awareness.

GUESSING

As you can imagine, taking care of a nonverbal child like Keli can be a challenge. As a parent, you constantly have to be guessing what he expects and wants to do. Automatically you start manipulating Keli, because you cannot read his mind. You have no way of getting to know his inner self, personality, expectations, dreams, wishes, favorite food, favorite color, and so on. Before Keli had the means to express himself, we, his family, were self-proclaimed experts in predicting his wants and needs. In our own opinion, we had developed a pretty good skill in

understanding his expectations. As it turns out, we hadn't. Since Keli has been able to express his thoughts by pointing out sentences on a letterboard, we have found out that pretty much everything we had assumed he liked, he doesn't, and vice versa. That has been a sobering experience. This shows us how impossible it is to get to know an individual who is locked behind the bars of autism.

To name an example, I was almost certain that Keli's favorite restaurant was McDonald's, just as his older brothers'. As it turns out, that's far from the truth. His favorite food is sushi—especially sunshine rolls and virgin rolls. His favorite restaurant is a certain sushi place here in Austin. Not exactly your typical fast-food joint. I had always thought his favorite color was blue, but we've found out he really likes the color red.

Specialists had told us that Keli had the mental capacity of a two-year-old. Our demands of him were therefore limited to what one would demand of a child of that age. If we read him a story, we assumed he didn't have the capacity to understand much, if anything. We sometimes read him *Teletubbies*—we genuinely thought that was his favorite literature. Now we know that his favorite authors are Mark Twain and J. R. R. Tolkien (he loves *Huckleberry Finn* and *Lord of the Rings*). Unfortunately, this goes to show that we, his parents, who believed we knew our child the best, were unable to guess what he liked or disliked. And that breaks my heart.

Communication Can Be Everything

A few months ago I noticed that Keli had a limp. Not for the first time, because Keli had been limping on a regular basis since he was a small boy, and I never knew what was causing it. Of course, I always took him to the pediatrician to find out why he was limping, again and again and again, just to make sure that everything was okay. His pediatrician couldn't find anything wrong with him and always assumed that he had twisted his leg.

It is challenging to diagnose a child who cannot speak. The child can't tell you whether he has a headache, stomach pain, or something entirely different, and often it is easy to blame the problems on autism. In many cases, however, autism has nothing to do with what is actually bothering the child, whether it be appendicitis or other medical problems. What made the

Still from *A Mother's Courage* (aka *The Sunshine Boy*), 2010.

crucial difference for Keli, when I noticed his limp a few months ago, was that he was now able to express himself. Using the letterboard, he pointed and spelled:

EMERGENCY, MUCH PAIN IN LEFT FOOT, DOCTOR TODAY

This time I could tell the doctor what Keli had communicated. He told me that under normal circumstances he would just have assumed that he had twisted his leg, but in light of what Keli had said, he ordered an X-ray of his left foot. The physician called me later that same day and wanted to meet me at his office. I was inundated with all kinds of questions about Keli's circumstances and his daily life. At first I had no idea as to where the doctor was going with all these unexpected questions, but then it dawned on me. The pediatrician clearly assumed

Still from *A Mother's Courage* (aka *The Sunshine Boy*), 2010.

that someone in the household was physically abusing my precious son. The X-ray showed that his left foot was broken. They also found four old fractures in his right foot, fractures that had healed over time. I realized that all the time he was limping as a small boy, it was because he had probably fractured his foot. But since the doctor simply diagnosed it as a twisted leg, nothing was done. These fractures healed by themselves, and Keli had no way of telling us the pain he was going through. As you can imagine, my heart sank. My darling boy had been in so much pain, and I had not been able to do anything about it. We had to take our Keli to many different specialists to deal with the healing of his fractured foot. He wore a boot on his left foot for two months. In the end, we got the verdict we all were so afraid of. After weeks of examinations, Keli was diagnosed with osteoporosis. This was a drawback and a drastic shock to all of us. But life goes on, and you have to make the best of everything. You have to keep going. You don't really have a choice, do you?

Mission Impossible

Being Keli's mother has been my own personal Mission Impossible. I have two other typically developing sons, so I have a firsthand comparison. Having a typically developing child, you never really have to worry about the basic things. You instantly become a part of the system. Your child goes to day care, then kindergarten, then school—each step is carefully choreographed by society. Nothing new, no surprises. Everything is as you expected having a child would be. When you have a normally developing child, you often say to yourself and others: "I'm so blessed to have a normal child." But you don't know. You have no idea. You have no inkling as to how it is to have a child with severe autism. Well, now I know. Having a child with autism is my life. I live it every day. It's real and it bites. Reality bites.

When I was young, I was taught you make your own luck. You control your own life and your direction into the future. But you have no control over whether you have a normally developing or a disabled child. And you have to come to terms with the fact that your life will be completely turned on its head, whether you like it or not. You have no choice. In a blink of the eye, your entire family life is capsized. One day it's the basic run-of-the-mill pleasant day-to-day life. The next it's a small family business based on the needs of a small child with autism. Everything revolves around his needs, looking for solutions to problems and ways to minimize his autism. Making him as independent as humanly possible, so that he is able to fulfill his own basic needs.

To be perfectly honest, my Mission Impossible almost broke my spirit. No matter what I tried, nothing worked. Despite taking years off from work to administer to Keli, I was not able to teach him how to imitate my actions, and imitation is the basis for learning to do things. He could not learn how to put on his clothes, he could not be weaned from wearing a diaper, and I had no luck in teaching him how to communicate. No luck whatsoever. It felt like I was on a treadmill, running for my life and his, without moving an inch forward. This really felt like a Mission Impossible.

And the truth is—and I'm not particularly proud to admit it—I had more or less given up. I had finally succumbed to the fact that Keli probably only had the intelligence of a two-year-old.

I disliked myself for not being more successful for my own precious offspring. Never in my entire life had I felt like such a loser. I felt like I had no success, no matter how hard I tried, zero. And what hurt even more was that this was my own son I was so desperately trying to help and heal, with all my heart and soul. I was torn and feeling empty, I was devastated, questioning my own abilities as a mom helping my son Keli.

My Sunshine Boy

But if I was not to have any success with Keli, I was determined to do something that could help the parents of other autistic children. I wanted to make a documentary about autism, so that future mothers of children with autism would not have to experience the same abyss of sorrow and hopelessness that I had. In my mind, it was imperative that they have more success with their children than I had had with mine. I wanted them to have more light in their deep and dark alleys than I had experienced in my own journey.

I thought it would be essential to do something proactive, since early intervention is so crucial for the progress of a child with autism, but Keli was diagnosed relatively late, when he was four years old.

So, I Made a Documentary

My original plans were to make a small, cute documentary on autism, basically being a scientific approach to the subject matter. The project was supposed to take six months. But as things go when you're working on something very close to your heart, the project became so much bigger than I had initially planned. The documentary evolved tremendously during the process and almost took on a life of its own. It was never my plan to include me and Keli in the movie. This was supposed to be a scientific movie about autism. Originally it was supposed to be titled *The Sunshine Boy*, but when marketing the film in the US, *A Mother's Courage* was thought (not by me!) to be a better-suited title.

This project truly was a turning point in our lives. Not so much in the fact that we made a successful documentary—that is in itself quite irrelevant. More in the fact that during the process, we finally reached Keli and got to know our beautiful little boy for the first time in

our lives. So, even if this undertaking was way bigger in scope and more time-consuming than originally planned, it has been a wonderful blessing for the family.

Basically, we were trying to achieve three objectives with the making of the documentary. The first objective was to raise general awareness of autism. The second objective was to represent the entire autism spectrum, making people realize that autism is a more varied condition than that reflected in the movie *Rain Man*. Third, we wanted to shed light on the many existing opportunities and possibilities in the treatment of autism, making it possible to minimize the effect of autism and making it possible for individuals with autism to take an active part in society. Our intent with this documentary was to lend a voice to these children, so that they could flourish and utilize their strengths according to their own ambitions.

Along with our personal achievement—breaking through the walls of Keli's autism—I feel that we really have achieved all these three goals. I am so thankful for all the attention this movie has received. The film has taken on a life of its own, bringing together the community of children with autism and their parents in a way I could never have imagined. I am humbly overwhelmed.

And Then There Was Kate

I first met Kate Winslet in a studio in London in August 2009, when she was recording the narration for the film. I remember being struck by her beauty; wearing no make-up and dressed casually, she was more beautiful in person than in any film I had ever seen. Her charisma and enthusiasm in narrating the film was deeply moving. It was as if I had known her all my life. She has such a gentle and pleasant presence. I know this sounds like a cliché, but she truly is a genuinely good and honest person. The kind you meet only a handful of times in your life. Since our first encounter in the studio, we have become close friends. She has been so much inspiration and support, for both Keli and me. What speaks the most to her nature and personality is the way she acts in the presence of Keli. In spite of what most of us would consider peculiar behavior by Keli, when he's walking around, appearing to be oblivious to his surroundings, she treats him like any other member of the family. She acknowledges him as an intellectual person, in spite of his autistic quirks that most people find a bit overwhelming and alienating.

I also truly admire Kate for all her compassion, kindness, and commitment to autism. This compassion is all the more admirable and unique, since she hasn't experienced autism firsthand as a parent or a family member. This speaks to her incredibly grounded character. I am in this field to help pave the way for my son and individuals with autism like him out of bare necessity, as a mom. She is paving the way for Keli and individuals like him out of the pure kindness and goodness of her heart. For that she will always have my most heartfelt respect and gratitude.

Shortly after that first meeting, I wrote Kate to express my gratitude for her kindness. We began exchanging emails. Kate was so inspired by the documentary that she asked me if there was anything she could do for Keli, myself, or other parents of children who live with autism. It was through our email correspondence that I shared my vision of creating specially designed campuses to meet the unique needs of adults with autism. I told Kate that, when I am gone, I want Keli to be in a place where he is respected as an intelligent human being, despite his autism and the strain and limitations it places upon him. I want him to flourish and prosper in his own right and based on his own strengths, like my other sons. I realize that although he can never be fully independent, Keli is intellectually capable.

THE BOY WITH THE GOLDEN HAT

So, the Golden Hat Foundation was born.

Kate is a woman who inspires those around her. She has a glowing, charismatic drive that infects those around her. So we decided to start a foundation. The name of the foundation comes from Keli's poem *The Golden Hat.* The primary mission of the Golden Hat Foundation is to draw attention to the plight of nonverbal people with autism, who require a viable means of communication, a safe and enjoyable place to live and socialize, and a future filled with pride and accomplishments. This is our dream for every person with autism.

We want people to know that behind their unconventional behaviors and communication difficulties, people with autism are thinking and feeling individuals who want and deserve respect and the opportunities to succeed in life.

I have high hopes for the Golden Hat Foundation. I truly believe that we can make a difference by bringing together the two contrasting worlds of autism and the rest of us. I sincerely believe we can make a world of difference.

I want to thank all the people who have helped me make this latest chapter in my Mission Impossible way less than impossible.

To begin with, I want to thank my mom and dad, Sigga and Eric, who always supported us and were there for us. My husband Thorsteinn and our three wonderful sons, Erik, Unnar, and Keli, who mean everything to me and without whose help and support, none of this would have been possible.

To all the wonderful participants in the film who shared their story with us. To wonderful Dov Shestack for giving us hope for Keli and to the remarkable, amazing Soma Mukhopadhyay, who taught Keli creative writing after teaching him to communicate by pointing on a letterboard. To the fantastic people in Keli's school for believing in him and respecting him as an intellectual human being. To the sponsors and contributors to the film, who made the film possible, especially Actavis, the main sponsor of the film, whose support made this documentary a reality. To my coworkers and crew, who shared my dream and vision. To the first lady of Iceland, Dorrit Moussaieff, for both graciously agreeing to serve as patron of the project and later introducing it to Kate Winslet. To Rosie O'Donnell, for her continued encouragement and love throughout this journey. To Sheila Nevins and Jackie Glover, for airing the film on HBO. To Dr. Kendal L. Stewart, for revitalizing our optimism for Keli's future progress.

I am so thankful to Kate Winslet for her passionate support in furthering the development of those living with autism who face extraordinary challenges. Not only did she literally provide them with a voice by narrating the film, she is also now giving them visibility in the world at large through her foundation. Thank you again to everyone who blessed this project along the way and special thanks to Kate for founding the Golden Hat Foundation and making the world glow with her compassion and kindness.

To find out more about what you can do to raise awareness about autism and make a lasting difference, go to www. goldenhatfoundation.org.

Now, imagine going to bed. Everything is as it is supposed to be, except one thing. Your senses are all mixed up. You sense your surroundings in a fragmented way. But you are assured. You know that you are among people who care for you. People who are willing to fight for you and do their best to lend you a voice. You close your eyes, knowing that when you wake up the next morning, you have the means to communicate your desires, wants, and feelings.

Now that's something to be grateful for.

Still from *A Mother's Courage* (aka *The Sunshine Boy*), 2010.

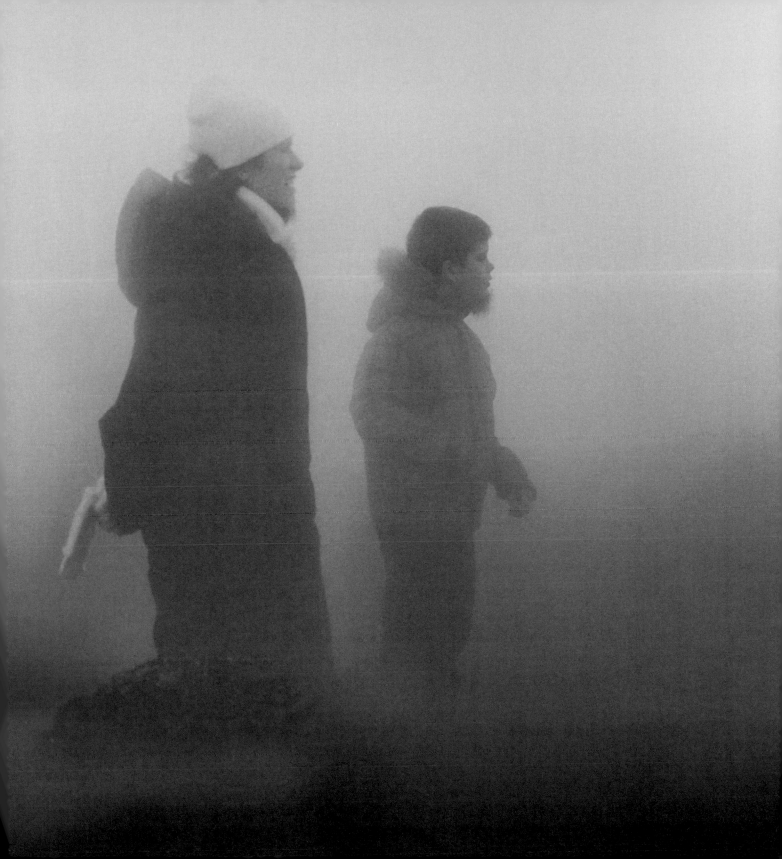

Keli has just been communication for about 3 months... He is not very experienced to communicate, but he is eager to learn...

Kelis writing:

Praying

I am praying.
Only God can hear my voice.
Telling you is no use

Dear God.
How many times must I feel sad?
I feel sad when daddy leaves.
I feel sad when I dont talk
I feel sad when I cant ask for help.
I am autistic.
I dont want to thank you for making me autistic.
You are God
I am sad
end

People I like:
1. Very patient
2. By me DVDs and take me to cinema
3. Take me to the park
4. Cool and good people

People I dont like:
Others (everyone else)

Happy hat regards,
Margrét and Keli

THE EMAILS

The following are emails between Kate and Margret. Included in these personal letters are stories of Keli, and his first communications after years of silence, the inspiring journey of the Golden Hat, and the beginning of the Golden Hat Foundation.

From: Margret D. Ericsdottir
Date: Sat, 5 Sep 2009
To: Kate Winslet
Subject: Keli poems

Dear Charming Kate,

I just have to share Keli's writing with you, I am so proud of him, and we all are.

For me it was so unexpected to get to know my nonverbal son with autism at such a late age of ten, and sometimes I don't know whether it is a reality or a dream.

Keli is discovering himself, just like we are now that he has started to communicate by pointing on a letterboard. Here is what he pointed today:

Keli is real, Keli is nice...

His writing is so sincere, so unpolluted and divine.
Keli writes:
I can make a poem on anything. (Here Soma his teacher challenges him, if you can write a poem on anything, then write a poem about this table you are sitting at.)

Table
A table is dry
Like the sky
Morning sun
So much fun
No more rain
Long long train
I am nice
First prize

And this he wrote yesterday; you know from the film that autism is predominantly a male condition.

Autistic Boys
God made autistic boys
Autistic boys like toys
They have no choice
They have no voice
Autistic boys are cool
Others think they are fool
Most boys have schools
Autistic boys like swimming pools

I keep all his writing, which I think is so lyrical and touching, at least for us.

Kate, I hope you realize that your contribution in narrating *The Sunshine Boy* is making A REAL DIFFERENCE for these children. With your narration these children are heard and the cause gets the attention it deserves.

Lots of love and gratitude,

Margret and Keli

From: Kate Winslet
Date: September 6, 2009
To: Margret D. Ericsdottir
Subject: Re: Keli poems

Dearest lovely Margret,

There is something that you should remember...
If it wasn't for your courage and determination to try and change the world for children with autism, then none of this would have happened.

It is YOU who is making the difference for all these children, and I am the grateful one.

I am so happy to be included in this enormous journey that you are on. Sometimes the most enriching moments in life can be found through other people. You and Keli have enriched and enlightened my life, and I feel very blessed for this.

I am ashamed at how little I knew about autism before meeting you, and seeing *The Sunshine Boy*. It is a great gift that you are giving these children and their families. A truly great gift.

You, Keli, and your family are remarkable people.

These poems have brought tears to my eyes. God bless your little man!!!!!
He's incredible. Just incredible. I too will keep these poems. They are utterly naked and profound. And so so so clear and honest. Just breathtaking to read.

Thank you. I can only imagine your pride.

My love to you ALL.

And please keep in touch.

Kate. Xxxxxxx

From: Margret D. Ericsdottir
Date: September 8, 2009
To: Kate Winslet
Subject: Re: Keli poems

Dear wonderful Kate,

You are definitely one of the nicest persons I have ever met.

Thank you for your encouragement, I so need it now. I am getting everything ready for the international premiere of the film for the Toronto Film Festival.

Wish you and your family good luck always,

Our love, Margret & Keli

From: Kate Winslet
Date: September 11, 2009
To: Margret D. Ericsdottir
Subject: Re: Keli poems

Hi Margret,

I hope you've had a good week down in Austin!!!!

I wanted to let you know that I have come up with an idea to raise money for Autism.

I will tell you all the details at another time, but I'm trying to secure some sponsorship to get this started.

What is the name of the charity that you would like money donated to?
Have you set up something in Keli's name? Would you like to? Let me know.

I'm so excited about this idea. It just came into my head when I was brushing my teeth last night. It involves a hat and a lot of very famous people!

All inspired by Keli.

Xxxxxxxxx

Love Kate. Xxx

From: Margret D. Ericsdottir
Date: Sun, 13 Sep 2009
To: Kate Winslet
Subject: RE: Keli poems

Dear wonderful Kate,

Yes, we are starting a foundation regarding autism, for a big international project we want to establish that will benefit these children directly. We the parents know where the need is the biggest.

I am now in Toronto with my soul mate, Thorsteinn, and Keli is in Austin with other parents who have children with autism. This is like our second honeymoon, since we have never been able to leave Keli with anyone before. But these are parents who have children with autism, so he is in safe hands.

Can I send you more writing from Keli? Let me know since I know that you are so busy...

All his writings move my heart and emotions like never before...

Lots of love,

Margret and Keli

From: Kate Winslet
Date: September 13, 2009
To: Margret D. Ericsdottir
Subject: Re: Keli poems

Hi Margret,

Wow...... How wonderful that you can be away with your husband. I know how rare those opportunities are, and I don't have a child with autism!!!! I salute you. I hope you're having some fun together.

I would love to see more of Keli's writing. I was also thinking that there might be a way to include his writing in this charity idea that I have. But you may already have considered doing something like that yourself, or you may feel that his writing is too private and too precious to be shared. Which, of course, would be understandable.

You can call me if you like. When you have more time.
We can talk properly then.

Love Kate. Xxx

From: Kate Winslet
Date: September 13, 2009
To: Margret D. Ericsdottir
Subject: Re: Keli poems

Oh, I almost forgot to say GOOD LUCK in Toronto. Xxx

From: Margret D. Ericsdottir
Date: Wed, 16 Sep 2009
To: Kate Winslet
Subject: Re: Keli poems

Hi dear Kate,

Funny regarding your hat idea... Keli has just written a poem, about a magical hat, The Golden Hat, and this golden hat could talk for a nonverbal boy with autism. With a foundation we can give these children a voice of their own, a meaningful life of their own. In that way it is symbolic of Keli's golden hat.

The Golden Hat
This boy had a golden hat
The hat was magical. It could talk
The boy did not have any voice. He had autism
His hat was always with him
His hat was lost one day
Now he had no way of telling them his stories
His mom and dad became sad
They taught him spelling on a letterboard
It was hard
End

Happy hat regards :o) Big hug xxx Margret & Keli

From: Kate Winslet
Date: September 16, 2009
To: Margret D. Ericsdottir
Subject: Re: Keli poems

Oh Margret,

The more we communicate, the more I'm starting to believe that it wasn't by chance that we met!!!!!

This poem is incredible. I think I need to find a golden badge or brooch to pin to the hat! I'm so excited to talk to you about this idea. I have a meeting

tomorrow with someone who is going to help me with sponsorship.
I will try and call you tonight when I have got my children to bed. I don't know what the time difference is between New York and Texas. I think it's one hour. Hopefully we can talk tonight.

All my love, Kate. Xxxx

From: Margret D. Ericsdottir
Date: Thu, 17 Sep 2009
To: Kate Winslet
Subject: Re: Keli poems

Dear Kate, thank you for the conversation last night,
This is all so beautiful and unexpected at the same time!
The hat idea is amazing, it is so different and unique in all ways. It's like there is a connection between you and Keli on this hat idea. Absolutely amazing.

Keli has just been communicating for about three months now, so he is not so experienced to communicate, but he is eager to learn.

Keli's writing:

Praying
I am praying
Only God can hear my voice
Telling you is no use

Dear God
How many times must I feel sad?
I feel sad when daddy leaves
I feel sad when I don't talk
I feel sad when I can't ask for help
I am autistic
I don't want to thank you for making me autistic
You are God
I am sad
End

People I like:
1. Very patient
2. By me DVDs and take me to cinema
3. Take me to the park
4. Cool and good people
People I don't like:
Others (everyone else)

Happy hat regards, Margret and Keli

From: Kate Winslet
Date: September 17, 2009
To: Margret D. Ericsdottir
Subject: Re: Keli poems

Hi Margret,

This is getting so exciting!!!!
Thank you for Keli's writing, again. It is so moving to read. And it's just glorious that he has a way to express himself, including his sad feelings.
I must send some DVD's. Then I can be on his "cool people" list!

I just had a great meeting with a man from the charity division from my agency, and he is going to help us to set up our Hat Project.

The first things you and I need to do are as follows:

My job (for now anyway) is to talk to my lawyer about setting us up as a registered charity and write my *ask letter* to send to possible participants in the book.

We also need to go through the mission statement ideas and decide on the charity's directors.

All my very best love to you and Keli.
Kate xxxx

From: Margret D. Ericsdottir
Date: Thu, 17 Sep 2009
To: Kate Winslet
Subject: Re: Keli poems

Hi Kate,
Thank you for the email
I am thrilled and so excited as well, this is so much fun...
I am working on this already, be in touch soon...

Lots of love, Margret and Keli

From: Kate Winslet
Date: September 17, 2009
To: Margret D. Ericsdottir
Subject: Re: Keli poems

Brilliant! Xxxx

From: Margret D. Ericsdottir
Date: Fri, 18 Sep 2009
To: Kate Winslet
Subject: Fwd: Great Variety review!

Hi my dear,

I have to share this great *Variety* review of *The Sunshine Boy* with you, see the link: http://www.variety.com/review/VE1117941130.html?categoryid=31&cs=1.

I am so proud and happy, because I am always so afraid that nobody will be interested in the film, since it is about autism. People have more sympathy and empathy with these children when they are small and cute children, but when they grow up to be adult individuals still with all these exaggerated and different behaviors, they don't get the same understanding. Of course, this is very understandable because people don't know any better......

Have a wonderful weekend with your family
Very warm regards,

xxx Margret & Keli

From: Kate Winslet
Date: September 18, 2009
To: Margret D. Ericsdottir
Subject: Re: Fwd: Great Variety review!

Hi lovely Margret,

I'm rushing so I will write properly later with more news.
Thanks for your emails. The review is wonderful. Really wonderful... This is a very big deal for the film, as everyone will tell you!!!! Hooray!

I wanted to let you know who I've got to do the hat photo so far:
Meryl Streep is doing it tomorrow!! So our first person is a mega star!!!!
Next week we have Naomi Watts, Maggie Gyllenhaal, Jude Law, Hugh Jackman, and Daniel Craig.

All very exciting.

Lots of love,
Kate. X

From: Margret D. Ericsdottir
Date: Sat, 19 Sep 2009
To: Kate Winslet
Subject: Why

Dear wonderful Kate,

Now I am ready to share with you why I made this documentary in a metaphorical way, even so, it is much closer to the truth than the documentary itself reveals.

It is a synopsis of story, a book, I started to write ten years ago and I call it the *Witches of Fate, Moirae*.

I originally started to write this for my own healing and general well-being since I could not afford therapy for myself to deal with all the pain and frustration within me. Inside I felt like a volcano of all kinds of harsh emotions which were just waiting to erupt since I just could not deal with all this pain within me.

I want to share it with you so you understand what I went through after Keli was born and our first three difficult years. I was getting to know this new world of autism, but I did not attach any real meaning to that word until Keli was diagnosed. I also want to share this with you so you understand how GRATEFUL I am for all your help, for giving these children a possibility of being heard, a possibility of having a meaningful life, and as inspiration for all the parents out there, giving them hope and encouraging them to move forward.

All our love xxxx
Margret and Keli

From: Kate Winslet
Date: September 19, 2009
To: Margret D. Ericsdottir
Subject: Re: Why

Dearest Margret,

Meryl Streep has just granted us the great honour of being our first famous person to take the hat picture. And the photo is GREAT!!!!!!!
When I can get to a proper computer, I will send you the pictures!
It's amazing the response that I am getting so far...
This could be big...... Really big!

In your email, did you send an attachment? Nothing was there for me to read. Please send it again. I'm desperate to read your story.

All my biggest love,
Kate. Xxxxx

From: Margret D. Ericsdottir
Date: Sun, 20 Sep 2009
To: Kate Winslet
Subject: Re: Why

Dearest Kate,

It is just almost unbelievable. It is such an honor!

This is so much fun, can't wait to see the picture, just when you have the time.

Big and warm hug from me and Keli

From: Kate Winslet
Date: September 22, 2009
To: Margret D. Ericsdottir
Subject: Re: Why

Hi Margret,

Well...... I'm sending emails out to so many people. Getting an incredible response!

Everyone is saying yes.
So far I've got (photos of)

Meryl Streep, Me, Maggie Gyllenhaal, Peter Sarsgaard, Ben Stiller.

And I've had "yes" responses from

Angelina Jolie, Leo DiCaprio, Natalie Portman, Mario Testino, Reese Witherspoon, Penelope Cruz, Javier Bardem, Pedro Almodóvar, John Krasinski, Emily Blunt, Jude Law, Daniel Craig (he's James Bond), Hugh Jackman (Wolverine!).

The list goes on.....

I still haven't been able to see your attachment.....
My stupid cell phone.
Can you send it another way?

All my love.

This is SO wonderful......

Kate. X

From: Margret D. Ericsdottir
Date: Thu, 24 Sep 2009
To: Kate Winslet
Subject: Group session

Hi dear wonderful Kate,

Keli had his group session recently which I wanted to share with you.

It is so nice staying here in Austin. The other boys with autism are typing and encouraging Keli by sharing their experiences. Some of them have keyboards which talk for them. They tell him that this is really hard to begin with but not give up on himself. The other parents are also encouraging me and Thorsteinn.

Keli had his first group session just recently. He has lived here in Austin the shortest. Most of the other boys have been here for few years, so they are really good in pointing and writing.

Keli is in group session with one other boy with autism who is the same age as Keli, twelve years old.

Keli's Group Session

Keli: Where do you live
Aidan: Round Rock. Where is Iceland
Keli: It is in Europe
Aidan: Maybe I can go there some day
Keli: It is very far
Aidan: I saw you come with your mom one day
Keli: My mom is busy today
Aidan: Do you like your school
Keli: I'm trying to behave well
Aidan: How is your school
Keli: It is fun. Is this your mom
Aidan: Yes she brought me here
Keli: Can you talk
Aidan: No I'm nonverbal
Keli: Me too

I am so grateful what you are doing for these children, it is truly admirable, dear precious Kate.

Happy Happy regards always to you and your family,

Margret and Keli x

From: Kate Winslet
Date: September 24, 2009
To: Margret D. Ericsdottir
Subject: Witches of Fate, Moirae

Dearest Margret,

Sorry that I haven't written since you sent your beautiful writing.
This week has been a bit crazy.

I was so deeply moved by what you wrote. The honesty of your words and the way
you were able to articulate so painfully your anguish and fear. I wept.
Your strength is overwhelming. Thank you for sharing these profound feelings
with me.

I have been sending emails out like crazy. I am still getting an amazing response.
I'll be sending the hat to Los Angeles soon, as there are so many people there
who have agreed to do this!

And Keli...... He's able to communicate with other boys!!!!!!!!!

Wow Wow Wow Wow. He must feel like a superhero. I love it when he says, "Can
you talk?" It must take such enormous strength and energy and courage for him
to ask that question.

Amazing.

All my biggest love,
Kate. Xxxx

From: Kate Winslet
Date: September 26, 2009
To: Margret D. Ericsdottir
Subject: Fw: From Kate Winslet

Dear Margret.......

I just got an email from Richard Branson.
I will meet with them next week
All my love. Woooo-hhhhhhoooo!!!!!

Kate. Xxxx

From: Margret D. Ericsdottir
Date: September 30, 2009
To: Kate Winslet
Subject: People

Hi dearest Kate,

All Keli's writing is usually affected by what is happening around him. He wrote this yesterday, and the subject was people.
There has been a lot of discussions here encouraging parents to vaccinate their children against the influences of the swine flu.

People
First people lived in caves
Next they made houses
Finally they lived in Mars
As they studied sciences

People are not penguins
They are not machines
People may have swine flu
If they don't take vaccines
End.

Flying crocodiles
There was a king
He lived long ago
He had many horses
They could fly
They took him to Egypt
In Egypt he saw flying crocodiles.
His horses had to be chased by those hungry crocodiles
He never let his horses fly to other countries
End.

... be careful.... watch out for the flying crocodiles....... Oooooooooouch!!
Careful Crocodile Regards,
xxx Margret & Keli

From: Kate Winslet
Date: October 6, 2009
To: Margret D. Ericsdottir
Subject: Re: Enriching

Dearest Margret,

Sorry that I haven't written to you for a few weeks. I have just been crazy busy. And today I'm making a small movie with Hugh Jackman! Very funny!

I am obsessed with the hat. I take it everywhere! It came with me to Paris last week and I got some wonderful actors to take their picture. And then, on Friday last week.....we got our first "famous couple" photo. Sting and his wife, Trudie!

Jude Law is in a production of *Hamlet* in New York at the moment. And tonight is the grand opening of the play. I'm not going to see it, because I saw it in London this summer. BUT I'm going to gate-crash the party after the show, with the hat!

There's bound to be loads of famous people there! Hee-hee-hee! I'm so in love with this whole idea.

Oh, Margret, I want you to know that the word is spreading about our hat. And I now have people ASKING to be a part of it... they have asked to take their picture for us!

I love your mission statement. It's absolutely wonderful and moving and honest.

I am meeting Richard Branson's company, Virgin Unite, next Friday the 16th of October.

I am constantly pressing forward.

I will let you know when it's time to present the documents to the government, because that is when we will need the mission statement to be ready.

I love Keli's poem...... Keep them ALL. I know you are.

Oh, how do I get a copy of *The Sunshine Boy* with the English narration on it? I have so many people who want to see it!

All my love,
Kate. Xxxx

From: Margret D. Ericsdottir
Date: Wed, 7 Oct 2009
To: Kate Winslet
Subject: fabulous

Dearest wonderful Kate,

The pictures are absolutely fabulous, thank you so much for sharing :o)
I loved all of them.

Our new situation with Keli communicating is so strange and beautiful at the same time, sometimes words are not descriptive enough to explain such new fluctuating emotions.

I am like on a total emotional roller coaster these days, and I thought it would not be possible for me to stretch my emotional spectrum anymore. But we are all so happy and thrilled getting the hope again, reenergizing us all, and leading us on this journey of small adventures with Keli each and every day.

Just getting to know him, what he likes/dislikes, his thoughts, dreams, and aspirations.

It is very hard for him to point on his letterboard and he has so much to say and you can sometimes see the frustration in his face. And now he is not as much in the creative writing but more trying to explain himself. It is so hard for him having autism, and he is telling us why.
Even though I have been reading books about autism and surfing on the internet since I had Keli, I am always so shocked how little I know about this complicated condition...

One small story from Keli, he really misses the dog we had in Iceland.

I feel ready to love a pet dog
Tomorrow I can go to a store and see some
I want to name him Sunshine Dog
I must produce my documentary and show to my friends.

Dear Kate, you are absolutely unique, and I feel so fortunate that you came into our lives. Thank you for being so giving and caring.

I love you, Margret & Keli

From: Kate Winslet
Date: October 9, 2009
To: Margret D. Ericsdottir
Subject: Re: fabulous

Dearest Margret,

I just watched *The Sunshine Boy* with my best friend, who is visiting from London. I feel so happy that your film remains intact and sincere, even with my voice replacing yours. It is still YOUR voice. And I'm so happy for this.

The hat is busy making its way around New York City. I am really concentrating on getting as many people as quickly as I can. I want to have a great presentation when I go and meet with publishers.

We have Kylie Minogue doing her photo on Monday! I've never met her before in my life, but through many different channels, I got her email address!

Also, I would really love to come to Austin to visit you, and to meet Keli, and your family.

Oh....... We have so much to discuss. I can't wait to talk to you again soon.

And maybe you could tell Keli that my daughter Mia (who is nine years old) has also decided that she is ready to have a dog as a pet. They have something in common...

All my love,
Kate. XxxxX

From: Kate Winslet
Date: October 14, 2009
To: Margret D. Ericsdottir
Subject: Hello

Hi Margret,

Is everything okay down there in Austin? I wrote you an email last week. I really hope you got it. I have got so many people taking their hat photo this week. So exciting.

How's Keli? Thinking of you both.
Love Kate. Xxxxx

From: Margret D. Ericsdottir
Date: Wed, 14 Oct 2009
To: Kate Winslet
Subject: Re: Hello

Dear Kate,

Thinking of you as well and I feel so relaxed and comfortable, and it's like a load of responsibility is lifted off my shoulders for helping these children, having you in the team with us.

I adore you for loving Keli and these children just the way they are, as opposed to how society wants them to be, to fit in our normal world. At the same time, I admire you for truly and genuinely caring about these special kids.

Keli wrote me a note while I was away. He loves me and missed me and wanted me to buy him a DVD when I came home. Of course, he got his DVD.
...Oops....... now I remember I always forget to send you the photos of us taken together in the studio, most of them are not in focus. Shall I send them to you?

xxx Margret & Keli

From: Kate Winslet
Date: October 14, 2009
To: Margret D. Ericsdottir
Subject: Re: Hello

Yes yes yes... Send please! I am rushing, Margret, I have to get the kids' homework done. I'll phone you tomorrow.
Love you a lot. Xxxxxx

From: Margret Ericsdottir
Date: October 17, 2009
To: Kate Winslet
Subject: His First Song

I also sent pictures of Keli watching music videos, like he wants to do, all day long. And he literally glows when he was pointing out his first song, like you see in the pictures. He was so proud and full of joy, it was pure pleasure watching him... and it was so cute when he pointed, "Oh yeah..."
There has been a lot of rain in Austin here in the fall...

Raining
Oh yeah
It is raining in my bathroom
I am hearing my shower
It is raining outside too
Like the sound of river
Oh yeah
I can not find my towel. Is it in a well?
Or flowing in a river?
It is raining in my shower
Oh yeah

Dearest Kate, isn't life just beautiful, if you can conquer the challenges you get in life, your spirit becomes free and happy...

Free and happy
I came in a car
I am a star
I have a friend
I don't intend
To go to school
No more rule
I am free and happy

I am even starting to use quotes from Keli's writing...

Margret & Gang x

From: Kate Winslet
Date: October 19, 2009
To: Margret D. Ericsdottir
Subject: Update

Hello, wonderful lady,

I am so sorry that I haven't called. It has been SO busy with the hat! It is now in Los Angeles, and people are getting ready to take their photos! So much to tell you. I promise, promise, promise to call you tomorrow. Too much to tell you in an email!!!!

All my love, to all of you, Kate. Xxx

From: Margret D. Ericsdottir
Date: October 28, 2009
To: Kate Winslet
Subject: Candy

Life is so beautiful, dear Kate,

The privilege we have now, getting to know our Prince Charming more and more each day, is just a great blessing...

Keli is discovering a new world like a candy shop full of all sorts of intriguing goodies. And in the process we are too. Now we are doing things all together as a family, instead of as usual, Thorsteinn with the other two boys and I at home with Keli.

I still do realize that Keli will always have severe autism and be restricted in that regard. But giving him the means to communicate opens the door to this delicious candy shop the world has to offer, in choices and possibilities, of rainbow colors and shapes.

And what always surprises me is that he wants the same thing as any other child wants, despite his limitations due to his autism.

We've been so busy fulfilling his requests and his desires. He loves bowling... can you believe it! Bowling of all places..... First, I was not even going to take him there... how was Keli going to play bowling with all his issues... but he can, of course he gets all these special things to help him to play it...

It is just so amazing, since he started to communicate, I found out that he likes things I'd assumed he would not be interested in, or capable of, because of his limitations. He has such a brave heart, our little man.

He wants to go to San Antonio, ice skating, fishing, boats, mall, the park, downtown...... I haven't been taking him ice skating, ...I can't see how he is going to ice skate, but he has been requesting twice now in a short period so probably I just have to try the ice skating hall here, like I did with the bowling, and see how it goes. I didn't even know they had ice skating here in Austin, but he knows...

Sweet candy regards, to all of you :o)
xxx Margret & Keli

From: Margret D. Ericsdottir
Date: Fri, 30 Oct 2009
To: Kate Winslet
Subject: Halloween

Charming Kate,

... and here is the Halloween story for the weekend... from Prince Charming Keli:

A man was on his way to work
His bag began to sing like a cat
He lost control of his hands
The car hit a lamp post
He died

Keli was bitten badly in the school in the arm, when asked who did it, Keli pointed ... I want to tell you, I learned long time ago, to forgive.

All our love,
Margret & Keli

From: Kate Winslet
Date: October 30, 2009
To: Margret D. Ericsdottir
Subject: Re: Halloween

Hello, wonderful lady!!

I am sitting on a train with Mia and Joe. They are listening to storybooks on their iPods. Although Joe appears to be dancing in his seat, so I think I need to check if he is listening to *Charlie and the Chocolate Factory* or Radiohead!!

I finally have a minute to myself. What a week! The hat has been in Los Angeles, and today we got Steven Spielberg!! You cannot imagine, Margret, the response to this idea has been incredible.

I am going to send you a list of all the people who have done this so far, and you can look any of them up on IMDB if you need to know who is who!!!!
Oh my gosh, and Elton John is going to do this too!!!!!

People really seem to be responding to the fact that I am writing to them personally and directly. And they ALL think that it is a wonderful cause. Everyone is so moved and impressed by your and Keli's story.

I love hearing from you. I love hearing Keli's stories. I love his conversations, his wit, his honesty, his compassion, and his courage. He is a remarkable little man.

Please keep all these writings. We MUST put them in the Hat Book.

But why was he bitten at school? What happened??? This is so terrible...

I am so sorry that I haven't phoned you. It's because I have SO much to tell you, and it will be a BIG conversation that we need to have. I have just been so busy.

I really want to come to Austin to meet your family, and of course Keli.

I'd better go now. The kids are telling me they're hungry. They always get hungry on trains!

All my love,
Kate. Xxx

From: Kate Winslet
Date: October 30, 2009
To: Margret D. Ericsdottir
Subject: Steven Spielberg

Hi, it's Kate.

Can you see the photo below? It is Steven Spielberg. Probably one of the most famous directors in the world. And he's wearing Keli's hat!!!!!!

Xxx Kate

From: Kate Winslet
Date: October 30, 2009
To: Margret D. Ericsdottir
Subject: Here's the list of people we have so far!!!

And on Tuesday I am driving from New York to Baltimore to get Michael Phelps. Don Cheadle, Angelina Jolie, Christina Aguilera, Catherine O'Hara, Ben Stiller,

Meryl Streep, John Krasinski, Emily Blunt, Demi Moore, Diane von Furstenberg, Mario Testino, Anna Wintour, Johnny Depp, Vanessa Paradis, Maria Sharapova, Naomi Watts, Liev Schreiber, Kyra Sedgwick, Kevin Bacon, Kim Cattrall, Cynthia Nixon, Chris Noth (Mr. Big!), Brigitte Lacombe, Ashton Kutcher, Jude Law, Ethan Hawke, Hugh Jackman, Daniel Craig, Maggie Gyllenhaal, Peter Sarsgaard, Natalie Portman, Penelope Cruz, Pedro Almodóvar, Sting, Trudie, Me, James Cameron, Marion Cotillard, Leo, Michael Caine, Ellen Page, Cillian Murphy, Ken Watanabe, Laura Dern, Steven Spielberg

From: Margret D. Ericsdottir
Date: Fri, 30 Oct 2009
To: Kate Winslet
Subject: RE: Here's the list of people we have so far!!!

OMG!!!
You are a SUPERWOMAN!

Keep up the good work! xxxx

Margret and family

From: Kate Winslet
Date: October 30, 2009
To: Margret D. Ericsdottir
Subject: Re: Here's the list of people we have so far!!!

By the way..... This is just the beginning! Xxxxx

From: Margret D. Ericsdottir
Date: Mon, 2 Nov 2009
To: Kate Winslet
Subject: IMPRESSED

Hi hi, was just landing..... back to Austin.

It was so much fun in LA, and we all enjoyed it so much, especially our little man :o)

Jonathon and Portia invited Keli for a sleepover. This is his first invitation to a sleepover. They did a special weekend for Keli and Dov, and they got to be such good friends. I will have to send you a video which Portia took of them together. They are all so nice and wonderful people.

This is actually the biggest change we find in Keli—now we can do almost everything with him because he behaves himself. Because now we know he understands, so we reason with him. This is so much freedom for all of us again as a family.
I want to tell you so many exciting things, but I gotta go to sleep now, my head is vibrating inside after the flight...

p.s.: Keli almost started to swim this weekend..... there are so many things happening with our boy.... I feel so blessed and I am so thankful, I am I am I am :o)

Big warm hug to you, Margret

From: Kate Winslet
Date: November 2, 2009
To: Margret D. Ericsdottir
Subject: Re: IMPRESSED

Oh Margret..... this email made me smile so much. We must talk. We have a lot to talk about. And I just cannot believe that Keli is learning to swim...... I just feel so happy. And I have to sleep too. With love. Xxxxxxxxxxxxxxxx

From: Margret D. Ericsdottir
Date: Wed, 4 Nov 2009
To: Kate Winslet
Subject: New York

Dear lovely Kate,

I will be in New York on Monday the 16th of November and fly back on Wednesday the 18th. Do you have the time to meet me in New York?

Then regarding your possible visit to Austin... Hopefully you could also meet the other moms and their children with autism while you are here. The other moms have learned the pointing method through their sons and have been showing the teachers in their school to use it. That is how we are pressing it through, gradually.

I am so happy with Keli's school and their staff, totally unique, respecting these children, fighting for them and assuming normal IQ despite their diagnoses..... Keli's teacher tells him an ancient Greek story of the marathon race. They sent a runner named Pheidippides to Sparta to ask for help... and she explained why the marathon is now part of the Olympic games. Also the reason why it is 26 miles (from the Olympic games in London in 1908). During his lesson she continually asks Keli facts about the story with choices. He does well, answering all correctly.

Our deepest gratitude, always Margret & Keli

From: Kate Winslet
Date: November 4, 2009
To: Margret D. Ericsdottir
Subject: Re: New York

Dearest Margret,

Thank you so much for your wonderful emails. I love reading them. And most of all I love hearing about Keli's progress. It is still so remarkable to me to discover all these wonderful things he has inside him. I can't imagine how it must feel for you. Heaven can't be as great as this!

I am definitely here when you come to New York, and we MUST meet!!! I can't wait to see you and show you all the incredible hat photos. I went to Baltimore yesterday with my children, to get the hat photo of Michael Phelps. He won eight medals for swimming in Beijing last year!!! And this afternoon, Ang Lee took his photo. It's so wonderful to be doing this!

I will do anything to help.

I am desperate to come to Austin. DESPERATE! I am not sure how to make this work.

I had better go. I am doing a big script meeting tomorrow, and I am completely unprepared!!!!

All my love to you, and the entire family.

Kisses, Kate. Xxx

From: Margret D. Ericsdottir
Date: November 6, 2009
To: Kate Winslet
Subject: Be Happy

Hi Miss Sunshine,

The flavor of the day......

There was a cat
She wanted to be a bird
She took some feathers
She stuck them to her body
She climbed a tree and she jumped
down and fell on her stomach and died

[Q: Question; K: Keli's answer]
Q: Is there a moral to your story?
K: be yourself, dont change your identity

Q: Is there anything you want to say?
K: I am not on facebook, I want to be
Q: What message would you like to share with the world
K: Be happy

If happiness would be the measure of normality in this world, than Keli would be perfectly normal, and the most normal in this household.
He is just such a happy kid and lively, sometimes I am torturing myself by imagining how much of an easy and loving boy he would be if he would have been typical developing, seeing the vision of him as a normal boy, walking, talking, running, cycling...

I know this is wrong and I should not be doing this, but sometimes my mind just goes there. It is not that I don't love him just the way he is..... because I surely do.... It is because I had always expected my children to be "normal" without giving to much thought about it....
Be Happy Kate,
xxx Margret & Keli

From: Kate Winslet
Date: November 15, 2009
To: Margret D. Ericsdottir
Subject: Re: Be Happy

Hello, wonderful woman.

I am so excited about seeing you on Tuesday. There is so much to tell you!!!!! Oh boy!

I can't write much now, as I'm travelling in the back of the car with my kids on either side of me. But why don't you come to our house on Tuesday at 12? If you have any trouble finding us, you can give me a call.

All my love. And safe happy travels!
Kate. Xx

From: Margret D. Ericsdottir
Date: December 1, 2009
To: Kate Winslet
Subject: Our King

Dearest Kate,

Really hope that you and your family had a good time in the UK.
For us, Keli's writing still stirs our emotions and challenges us in a way.

Maybe this is just us, but both me and Thorsteinn, we often find that he is writing about his experience in a metaphoric way...

The King
There was a king in a big country
He grew up on a tree because he was brought up by birds
He sang like birds and he tried to tweet like them
One day he was spotted by a man
He was singing on a branch of a tree
He was brought down and given education
It was hard work for many years
When he grew big he became clever man and great soldier
Slowly he grew to be a king
End

Like this story, Keli has been invisible for so many years, never spoken to, but spoken about, in front of him. So different from the norm, ignored unintentionally, isolated, never fitting in...

Now he is spoken to, given education and challenges and choices of everyday life.

And even though he enjoys it, being part of the world, being one of us, we know that this is very hard for him especially to begin with.

I don't know if I told you, but Keli's nickname has been The King in the household since he was about one year old. His older brothers gave it to him, because during the first year he needed my devoted attention solely. They even made a poem about The King with their dad, which is decorated in one of our windows in our house in Iceland. His brothers understood why I had to spend so much time with Keli,he was always so sick. They would say to me, "It is ok Mom, just take care of The King. We can do this by ourselves."

BIG HUG to all of you, can't wait to see you here in Austin, hopefully soon...

Margret & The Gang

From: Kate Winslet
Date: December 3, 2009
To: Margret D. Ericsdottir
Subject: Re: Our King

Hello, lovely Margret,

I am so happy to hear from you. As always.

So... The King. Well, his writing is just incredible. And you are right, it is deeply metaphoric in so many ways. And so poetic and SO SO intelligent. He is extremely clever! I cannot begin to imagine how overwhelming it must be for you

and Thorsteinn to read these words that pour out of Keli's beautiful little soul.
It's breathtaking for me, and such an honour to be included in this miraculous
journey that he is on. And that you are on, with him, by his side!
Wow.......

In terms of the Hat Project. It is still going strong. So I'm getting back into
it this week. I'm starting to send out more emails, and scheduling appointments
with more people to take their photo before Christmas.

I have to run now, to go and pick up my children from school. But we will speak
soon. And I send you ALL lots and lots of love.....

Kate. Xxxxxxxxxx

From: Margret D. Ericsdottir
Date: January 5, 2010
To: Kate Winslet
Subject: Slow and Gradual

All my three boys are now living with us again—as you know, Erik just moved
back from Iceland. Keli's progress has united us as a family and given us hope
and optimism to keep on going. We all feel so blessed and happy even though we
all realize that this is hard work each and every day, and requires a lot of
dedication and commitment.

We have to be really patient, since this takes a long time, and it comes in
tiny steps. First, he could only point with Soma, then slowly and gradually he
started pointing with me, then his schoolteachers. First, he learned in a calm
peaceful setting and then very slowly he generalized to new places and people,
depending on when he is ready. Eventually he will be able to type on a computer
by himself—so exciting! But this process can take years depending on the motor
skills of the student and his severity of autism. You must understand this is
no miracle solution and all his progress is slow and gradual, but all this hard
work is worth EVERY minute, setting their spirits Free!

One of the main benefits I feel now is if he is feeling bad or moody, he can
communicate with me where the pain is........ that is such a relief, all these
years I had to rely solely on my intuition if he has been sick or feeling bad.

Keli is like a sponge; he absorbs everything in his environment and surroundings,
and even though he is stimming and behaving abnormally, he is still listening. He
probably has been like that all the time, but then we did not know. We can see it
so clearly in his writings since he writes about everything which is happening
around us. When we are traveling, talking, discussing, reading stories to him,
you can always see his version of that story in the next creative writing session.

There was a terrible storm last night and Keli woke up with all these thunders and
lightning and just laughed. And the traffic here in rush hours... Oh boy oh boy.

Poem from Keli:
Horrible traffic
Terrible night
Possible storm
Laughable sight

Sweet warm hug to all of you, xxx Margret & Keli

From: Margret D. Ericsdottir
Date: January 7, 2010
To: Kate Winslet
Subject: My Greatest Teacher

Dearest Kate,

Keli has been my greatest teacher in life, though I would never wish any other parent to learn this way, and I wished I would have learned in another way... When facing the reality of autism, you start to look at life in a different light. You become more tolerant towards other people, more humble and grateful for the things you have.

The little things start to matter. When the light turns red at an intersection in your car, you cherish the rare moment of relaxation, instead of cursing your bad luck, like you did before. When you get 10 minutes to drink your coffee and read the paper in the morning, you're extremely grateful.

Now, when I look at my boy, who probably does not process sounds and sight at the same speed and likely has limited sensations in his arms and legs, I am truly grateful for being a healthy individual and being able to take care of myself without the help of others. As a result, you appreciate life more and become happier and more joyful than before, not that I was depressed or a sad person before I had Keli...

I have learned the hard way that nothing should be taken for granted; that is my everyday reality. I am so grateful for what you are doing, and I really hope one day that I can do something for you, as precious, in return.

With sincere gratitude and lots of love,
Margret & Keli

From: Margret D. Ericsdottir
Date: January 10, 2010
To: Kate Winslet
Subject: Why, the Golden Hat Foundation

Dear wonderful Kate,

I do have a dream for Keli and other children with autism. They are growing and

getting older, as well as we the parents. Our dream, in the beginning, is to create a campus for those with autism, where they can live and work with the social assistance each and every one needs, as intelligent human beings.

This is the sole and only reason I wanted to start a foundation—to be able to create and establish a community like this for adults with autism, because this is where services are most scarce and the most challenging.

I want Keli and others like him to be in a place where they are respected as intelligent human beings, despite their autism and the limitations placed upon them. I want Keli to be able to flourish and prosper on his own ground, like my typically developing boys, and be in an environment which supports his strengths and his limitations. I want Keli to be spoken to, not spoken about, in his presence. I cannot leave this place until his future is secure.

I found out just recently that he is such a nice and intelligent individual, and this is the least I have to fulfill before I get too old to be able to implement it. This community would in the future hopefully be self-sustainable. They would be copied or franchised everywhere in the world. The individuals with autism and the employees would have the opportunity of changing their locations to any of these campuses. That way they could travel and get to know different cultures and atmospheres.

In my vision I see two role models; here in the USA and Iceland in Europe to begin with. Then it could be established globally, possibly in connection and coordination with respected universities. These nonverbal children/adults would work and learn to communicate through alternative methods. The environment would be designed according to their needs, strengths, and limitations due to their autism.

These are just my suggestions and draft as a base for the foundation. I feel I need to ensure the future for Keli and children like him before I leave this world, because as of yet, the system is not addressing these individuals and allowing them to live to their full potential. These campuses would prepare them for life—not for institutions, like most schools are doing now. They could live and work there when they get older and when we their parents can no longer take care of them.

I truly love you for all you are doing, xxx Margret

From: Kate Winslet
Date: January 11, 2010
To: Margret D. Ericsdottir
Subject: Re: Why, the Golden Hat Foundation

I love you too, my darling!
You are a rock, and inspiration and a life force.
I am so happy I know you...

All my love, Kate Xxx

FIRST WORDS

The following are portraits of individuals with nonverbal autism. These are some of their first words, communicated after years of silence via nonspoken communication methods.

him, and we

tic son at

s a reality or

started to

by Soma. Here

e, so

you can write

by)

sm is

uching, at

I am real.

Keli Thorsteinsson, age fourteen
Began communicating at age ten

I suddenly realized that Keli had been listening to us the whole time and he could understand everything that was going on around him. I have always felt so close to my son Keli. But I truly first met him when he started to communicate by pointing on a letterboard at the age of ten.

Margret D. Ericsdottir, Keli's mother

Teeth—Hurt—Help.

Carly Fleischmann, age fifteen
Began communicating at age eleven

This was her first words she typed.
We were stunned and shocked . . .
but then we were trembling with joy and
gratitude and we wanted more!

Tammy Starr, Carly's mother

Try fully to understand my
condition, because I get so lonely.

Josh Andrus, age twenty-five
Began communicating at age nineteen

This made me very sad;
Josh likes to be alone, but I didn't know he felt lonely.

Celia Andrus, Josh's mother

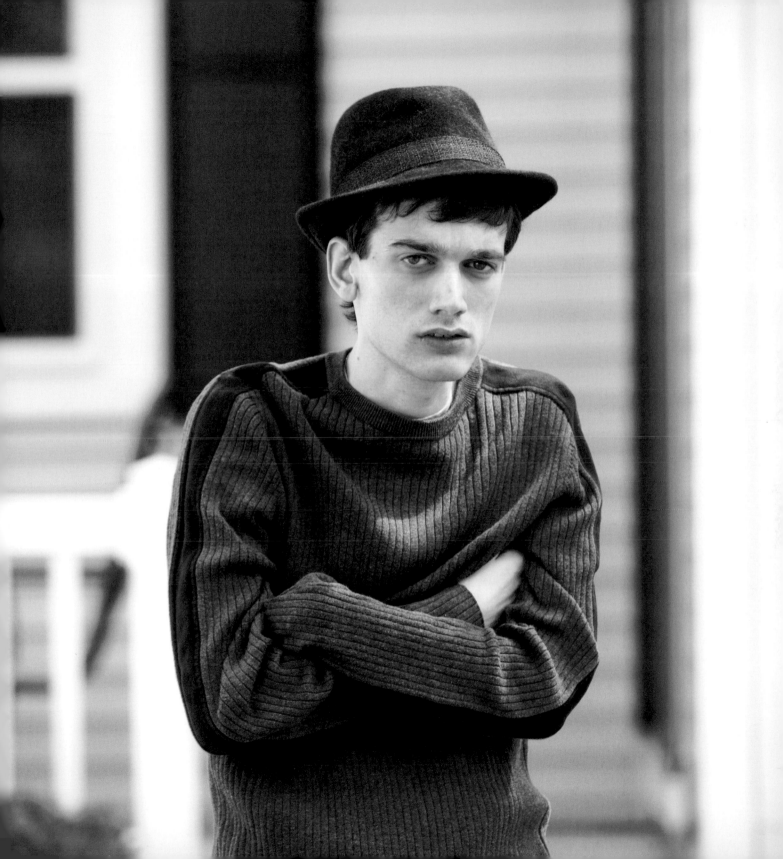

You are good to find a way of teaching me.
Please. Friends are important.

Jeremy Sicile-Kira, age twenty-two
Began communicating at age thirteen

When I saw what Jeremy was typing, I was joyful and amazed.
Joyful because he was thanking me and acknowledging my efforts
to reach him. Amazed that he brought up the notion of wanting friends,
as his body language did not show that he was interested in other
people. These simple words helped me understand that he wanted
what we all want: relationships with others and the opportunity
to learn. Having a voice through writing has changed his life.

Chantal Sicile-Kira, Jeremy's mother

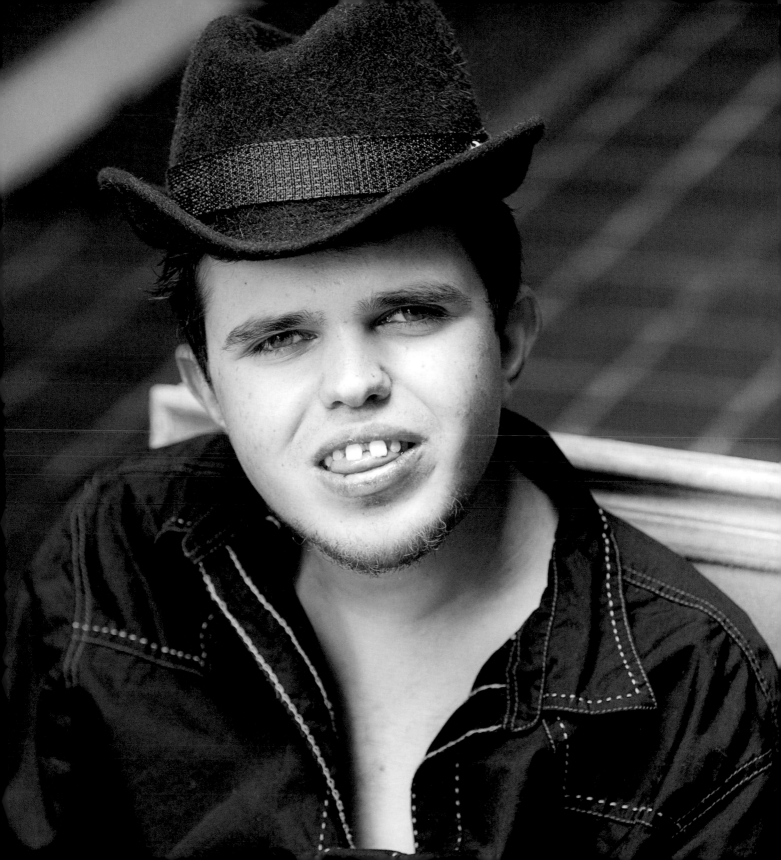

I don't like flattery.

Madison Lange-Wattonville, age fifteen
Began communicating at age eight

It was many years balancing a tight-wire act between
hope and reality. I waited, grieved, wondered, and worked
towards Madison being able to communicate, not knowing if
she ever would. So once Madison's open-ended expression emerged,
every day became a thrill and joy to finally hear her opinions,
thoughts, and subtle sense of humor.

Linda Lange-Wattonville, Madison's mother

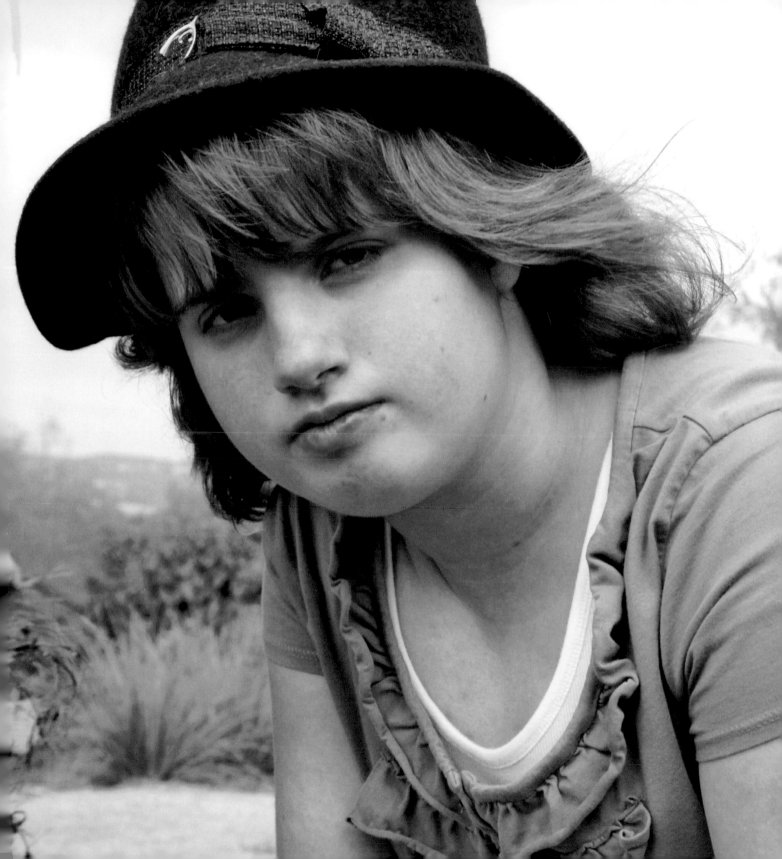

Stop the war.
It is killing too many soldiers.

Mike Weinstein, age seventeen
Began communicating at age eleven

I was dumbfounded. I almost fell out of the chair.
I had no idea he even had knowledge of the Iraq War.

Charlie Weinstein, Mike's father

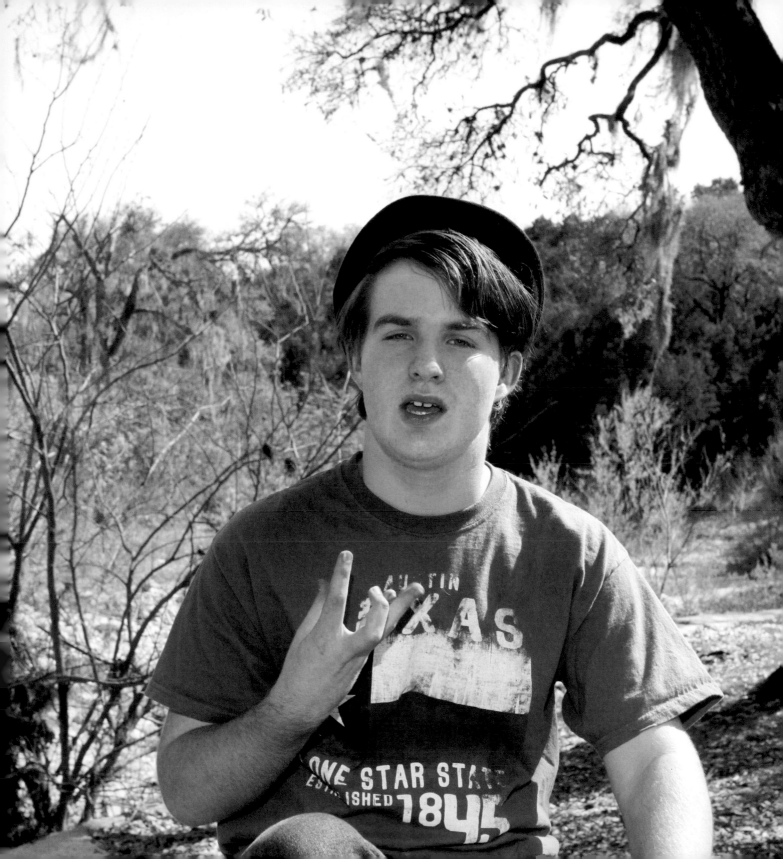

*Q: What would you say on a
radio show about autism?
A: Autism keeps me inside without a voice.
Q: Do you have a voice now?
A: Yes.
Q: How does that make you feel?
A: So articulate.*

Andrew Rhea, age fourteen
Began communicating at age nine

Every person has the right to be able to communicate with others.
Having conversations with our nonverbal son are what he so craves,
and so deserves. He now looks towards the future with high aspirations,
and hopes to find a world full of acceptance of all people.

Lynne Rhea, Andrew's mother

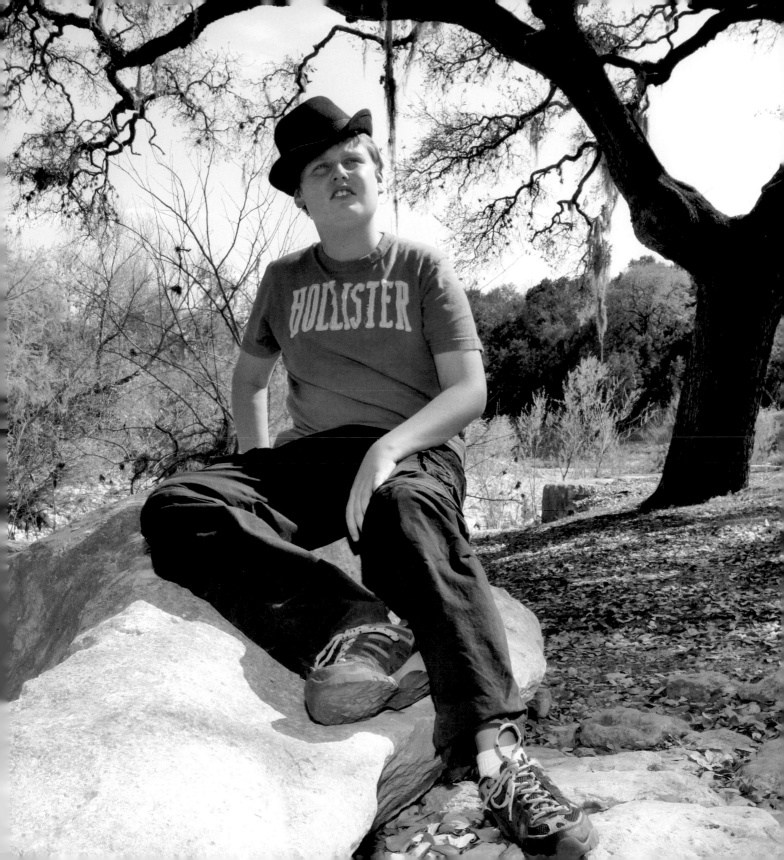

Listening.

Dov Shestack, age nineteen
Began communicating at age nine

This is what he answered when asked,
"What have you been doing all these years?"

Portia Iversen, Dov's mother

Mom, I'd like to put you on the spot.
You need to be more of a listener.

Neal Katz, age seventeen
Began communicating at age nine

I was blown away and in tears. He was right: as a single mom, I had been so involved with trying to make ends meet, plus create and run the Miracle Project, that I wasn't listening to all the ways that Neal was trying to communicate with me. Our relationship changed drastically from that day forward. Today, Neal is 100 percent involved in all decisions that effect him. Today, because of Neal, I listen. My motto is "Listen to the child who does not speak."

Elaine Hall, Neal's mother

There is a big rock in my shoe.

Mitch Helt, age sixteen
Began communicating at age ten

I thought he didn't want to go to church and was throwing a tantrum by taking off his shoes. I kept putting them back on; he would cry and throw them off again. Then he pointed out this first sentence at the age of ten. I cried. I thought, how many other times had he been misunderstood?

Lisa Helt, Mitch's mother

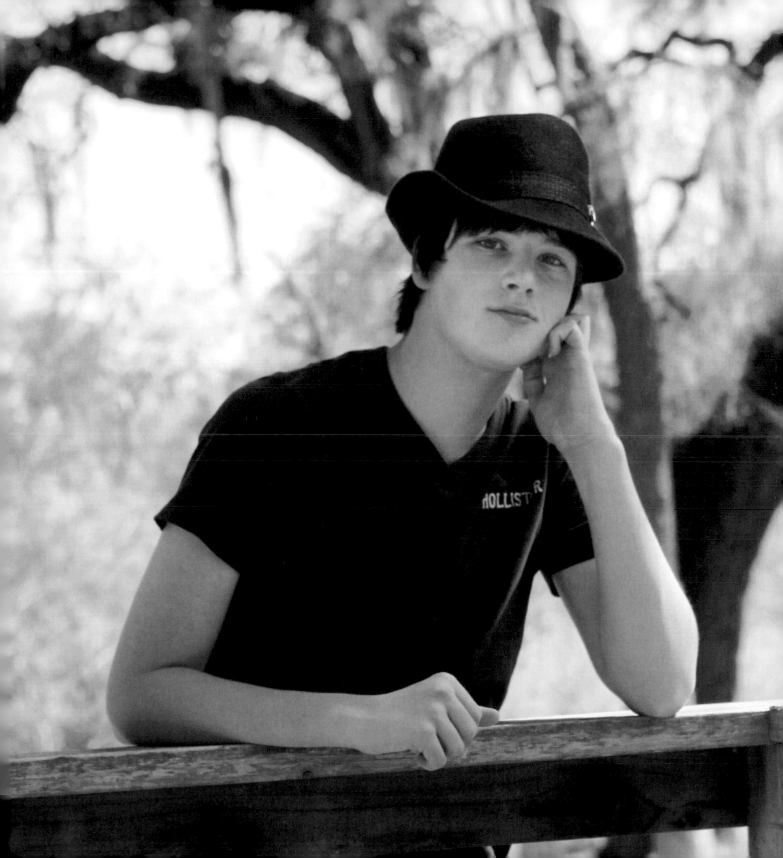

It was education that helped me enrich my imagination with all those probable and improbable reasonings based on science and philosophy, so that I could write my imaginings down as stories or as poetry.

Tito Mukhopadhyay, age twenty-three
Began communicating at age three

There is no justifiable excuse for depriving a group of individuals of exposure to knowledge and an academic education simply because of their uneven cognitive development and impaired sensory-motor function.

Soma Mukhopadhyay, Tito's mother

* While these are not Tito's first words, they illustrate how vital education is for individuals with nonverbal autism.

SELF-PORTRAITS

" So I came up with this idea . . . to send my favorite beaten-up trilby to as many well-known people as I could track down and ask them to photograph themselves wearing it! "

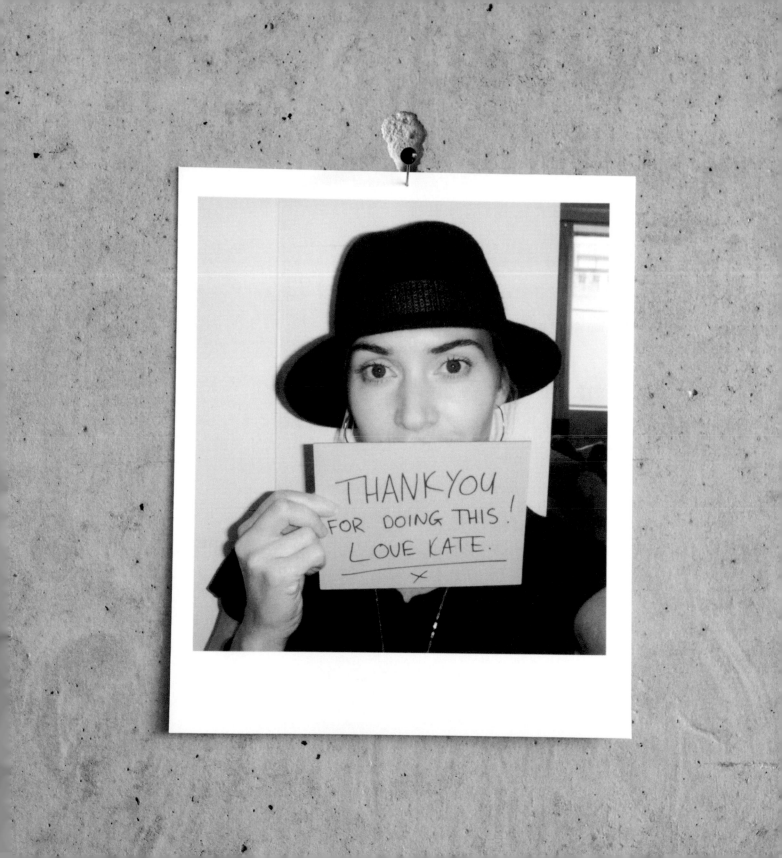

I hope this finds you well.

I'm writing to ask you a small favor. I could give you the long version, or the short. I'll go with the short . . .

Basically, I've had an idea to raise money for autism. I've never done anything like this before, so I'm still putting the idea together. Bear with me . . . Let me explain.

Last summer I recorded the English-language narration for an Icelandic documentary called *A Mother's Courage* (aka *The Sunshine Boy*), directed by Fridrik Thor Fridriksson. It's about a boy with autism named Keli, who has only just learnt how to communicate using an extraordinary letterboard technique, at the age of ten. It has already been distributed in Iceland, and judging by the response of audiences so far, will be a huge success.

Needless to say, I was deeply inspired by the film, and more importantly, educated about this condition, which I knew shamefully little about. After meeting Keli's mother Margret D. Ericsdottir, I was deeply touched by her journey to find a way for her nonverbal son to learn to communicate. Margret and I became friends, and together we decided to set up the Golden Hat Foundation in order to provide support for nonverbal individuals with autism and their families. Guess this is turning into the long version . . . Sorry!

Here's my idea:
To produce a book of photographs of well-known people all wearing the same hat. My favorite beaten-up trilby, to be precise. They would all be self-portraits, taken on my basic digital camera, which I will send along with the hat. It will be passed (very carefully) around the world and worn (I hope) by many. I'll get it to you, and collect it when you're done.

The only instructions are:
1) The photo must be a self-portrait.
2) The hat must be featured in the photo, either on your head or otherwise.

3) We would like a quote to accompany the photograph.
 Please consider the following scenario in drafting a brief quotation: It's hard to imagine being deprived of the means to communicate. Imagine a wall between you and those you love, imagine being trapped inside yourself, never able to express your desires, needs, feelings. Then imagine the loss to those around you. Those who love you but assume that you can't hear them, don't understand them, can't relate to them.

When Keli first communicated at the age of ten, this is what he said:
Keli: "I am real."

This was his mother's reaction:
Margret: "I realized that Keli could hear and could understand, he had been with us all the time."

Here are other examples of Keli's friends, who are also starting to communicate for the first time:
Carly: "I don't want to be this way. But I am, so don't be mad. Be understanding."
Josh: "I have never had coffee. I would like to try it."
Mitch: "There is a big rock in my shoe."
Will: "Take me to Europe and show me the Alps."

Put the hat on your head and think about how much we take communication for granted. How would you communicate who you are in a quote? What would your words be? Express something that's important to you.

Here is my quote: "I'm here, and I love you."

Thank you so much for your time and support. It means a great deal to me, and more importantly, to the individuals with autism, not only whose struggle, but potential, is so often tragically overlooked.

KATE WINSLET

I'm here,
and I love you.

Kate Winslet

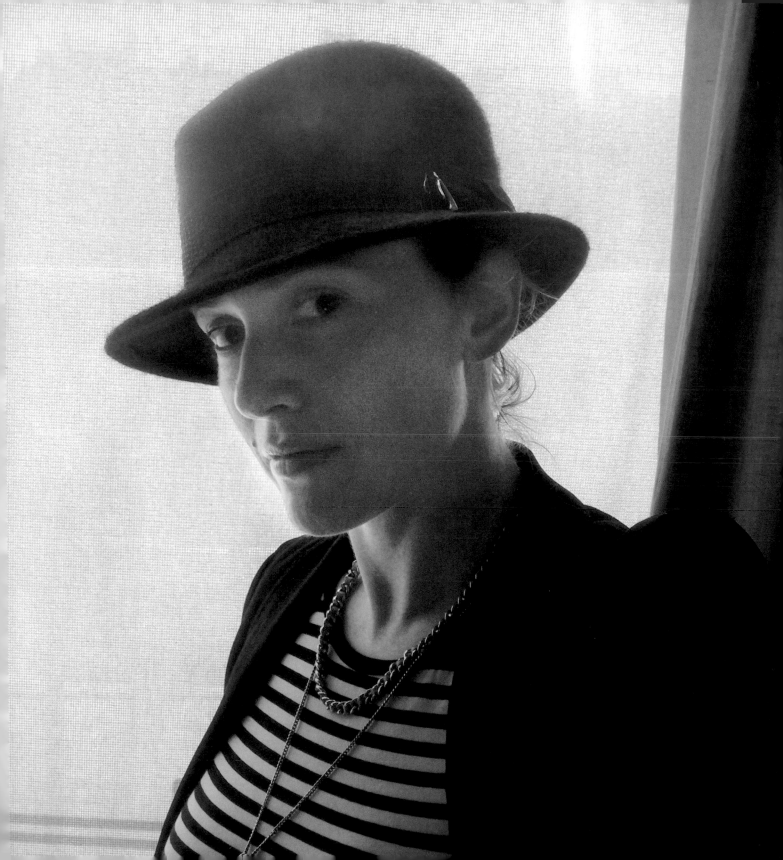

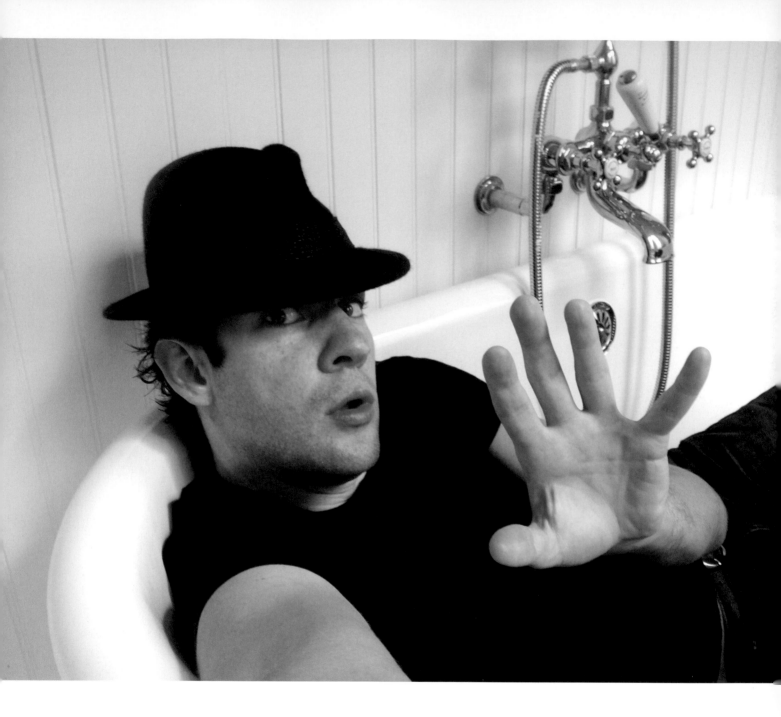

Let's take a chance!

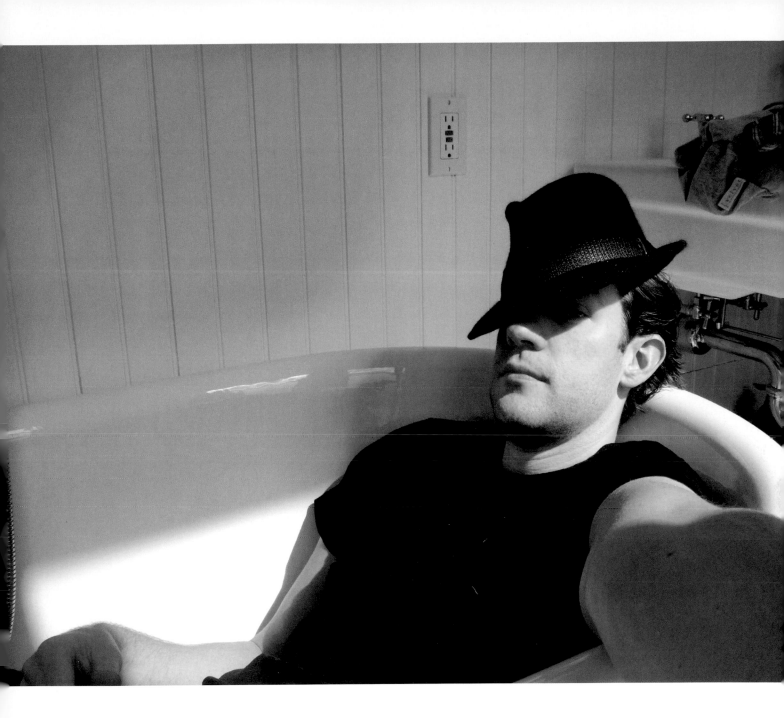

John Krasinski

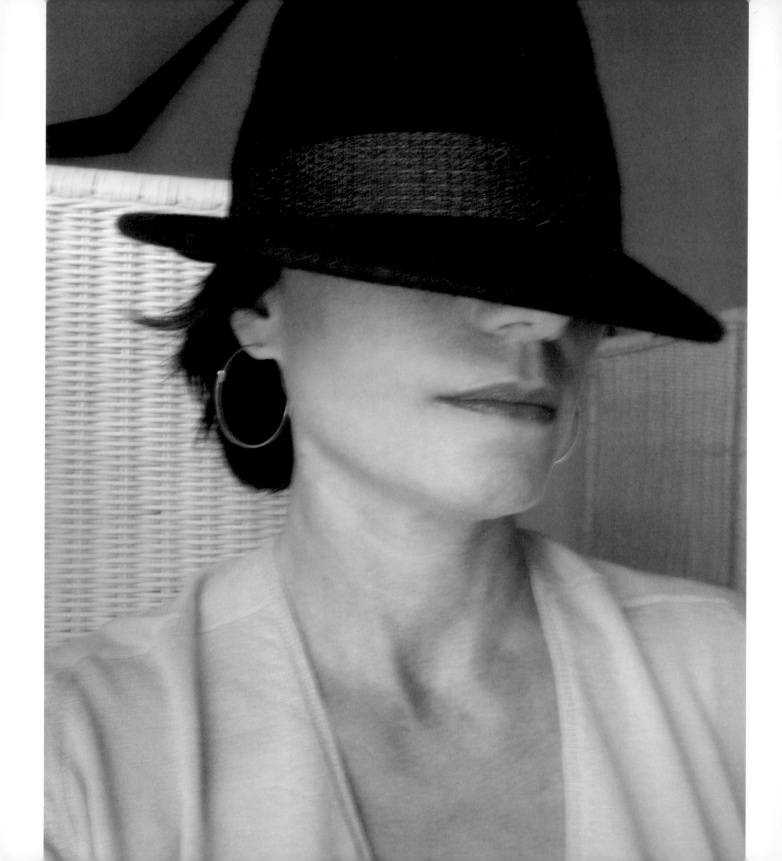

Happy, sad, busy, still, loud, secretive, funny, mean, kind, private, generous, worried, relaxed, sharp, sweaty, pretty, ugly, scented, selfish, thoughtful. Loving. That's me. I think . . .

Kristin Scott Thomas

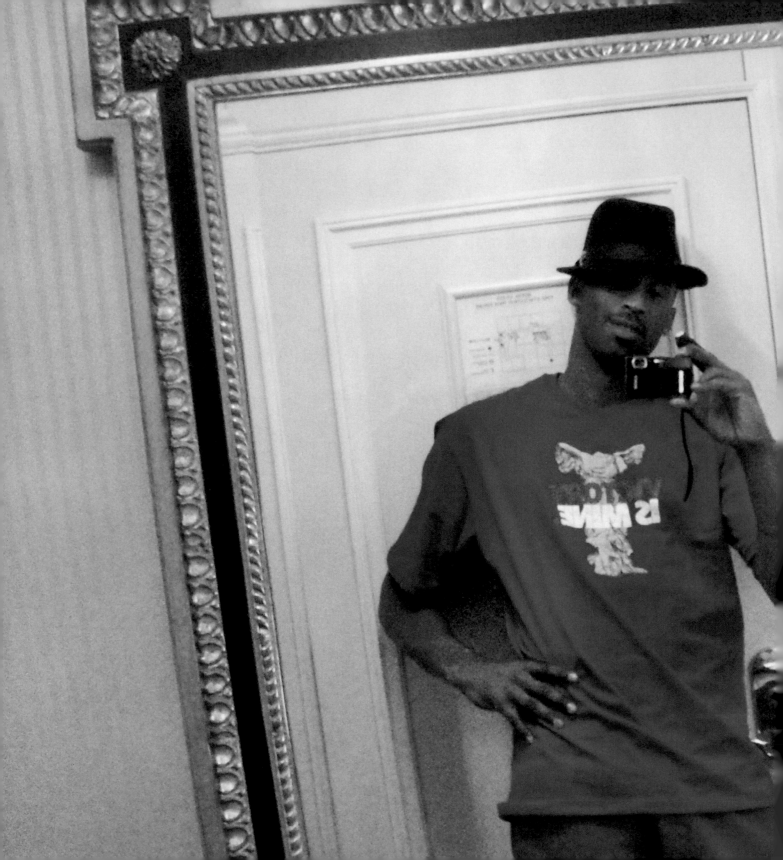

Carpe diem.

Kobe Bryant

*How does this damn
thing work anyway?!*

Christoph Waltz

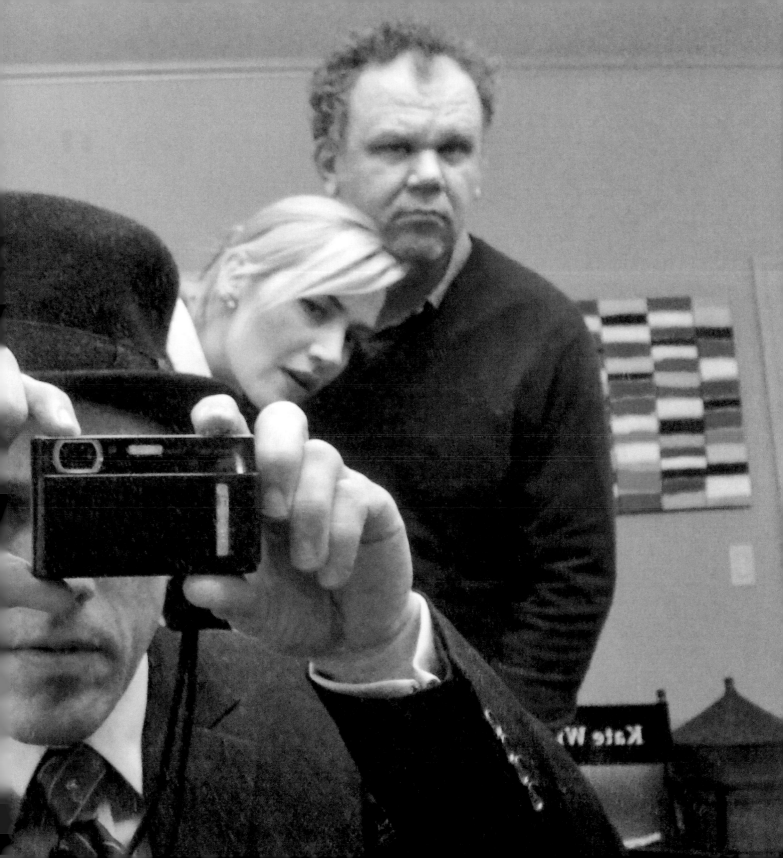

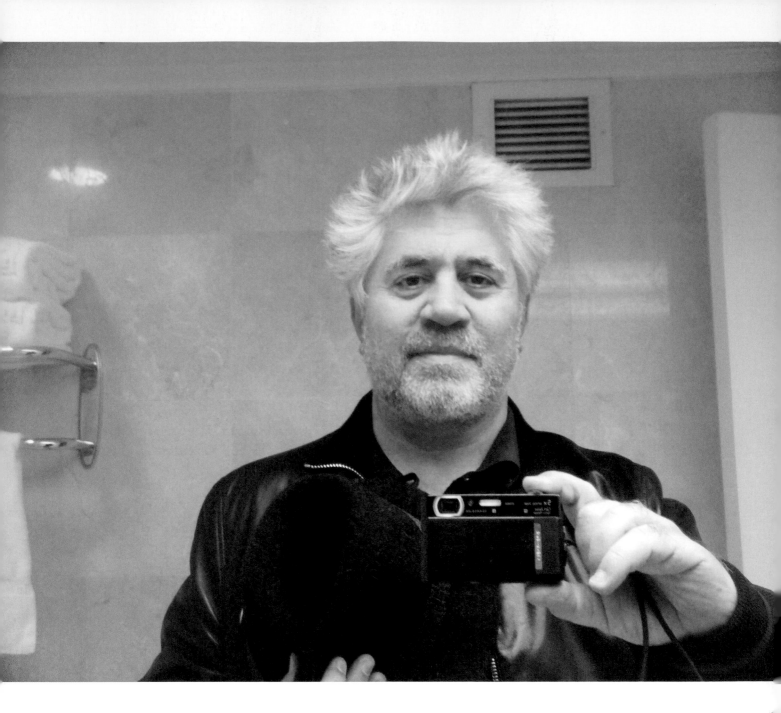

Hats never looked very good on me.

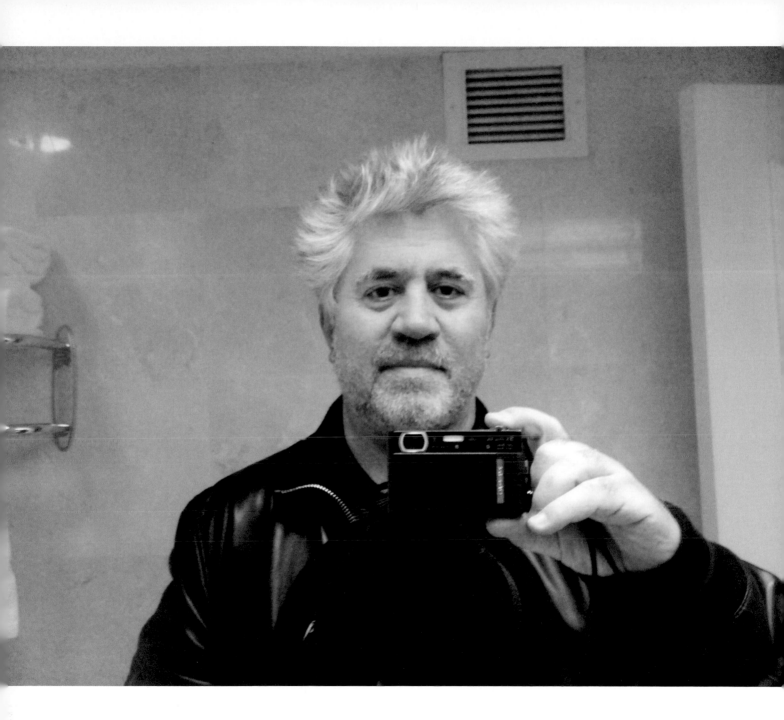

Pedro Almodóvar

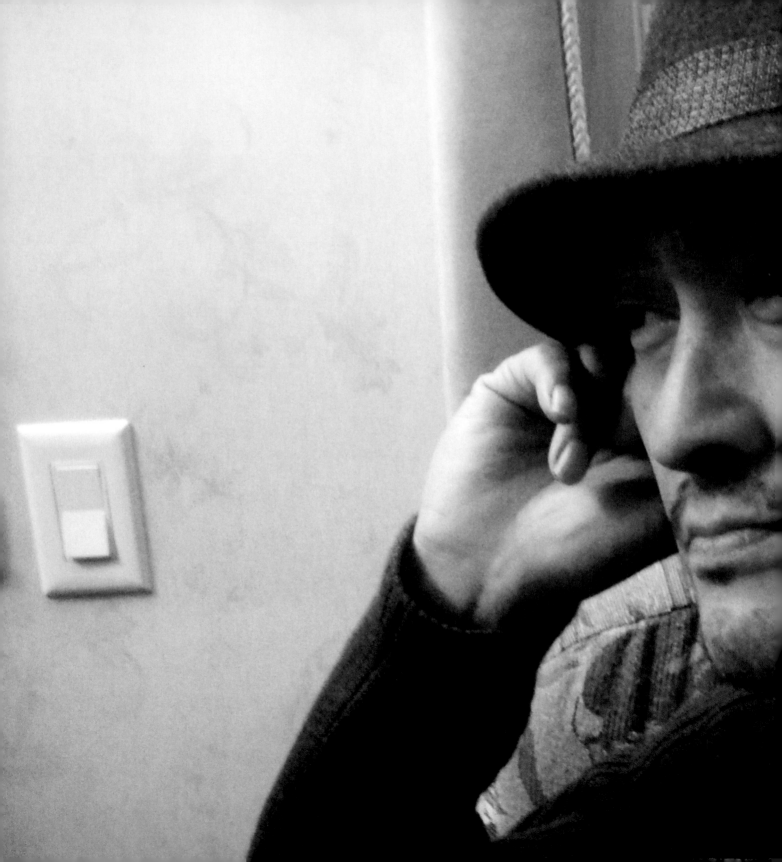

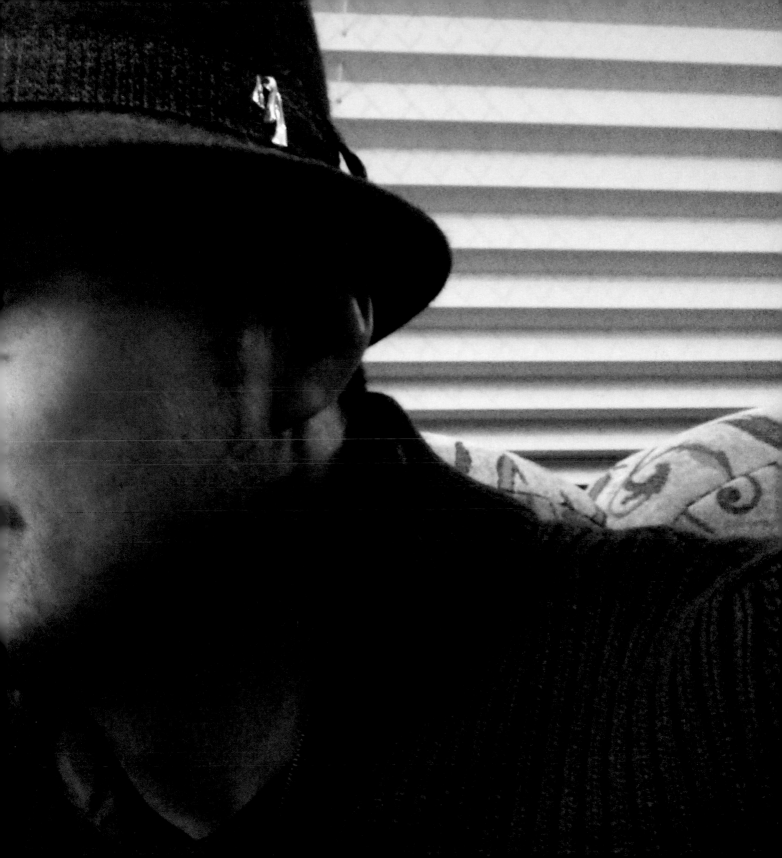

My heart is always beating.
My heart is always feeling.
I know you understand.

Ken Watanabe

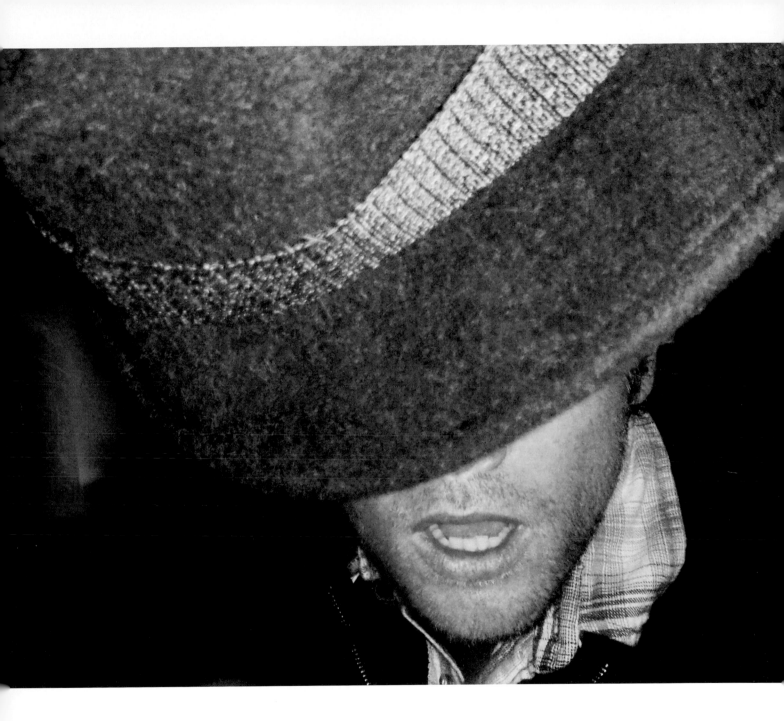

Sam Worthington

Is anybody listening?

Emily Blunt

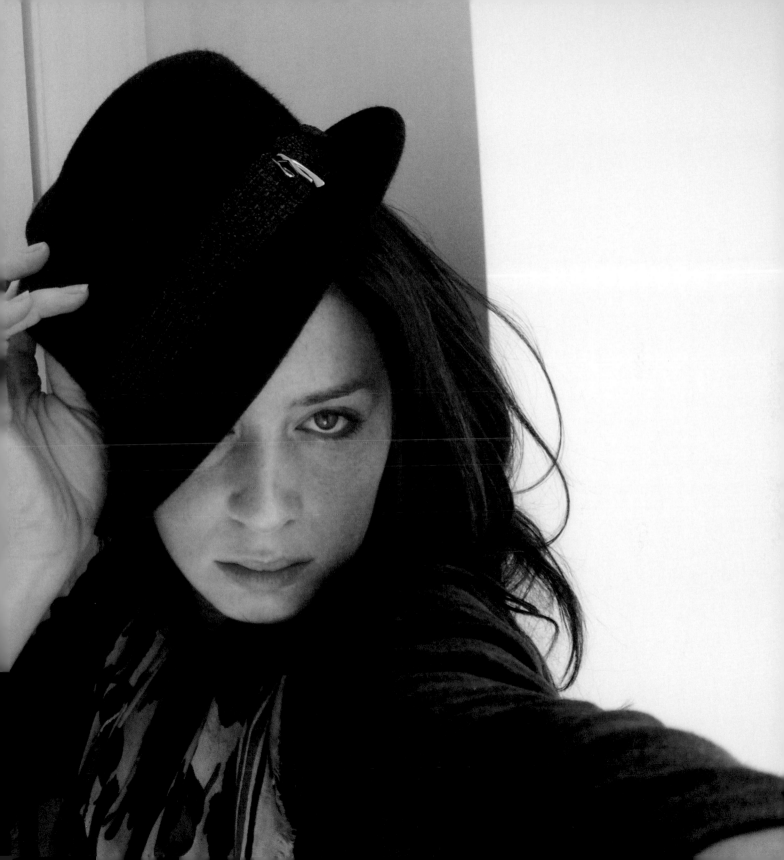

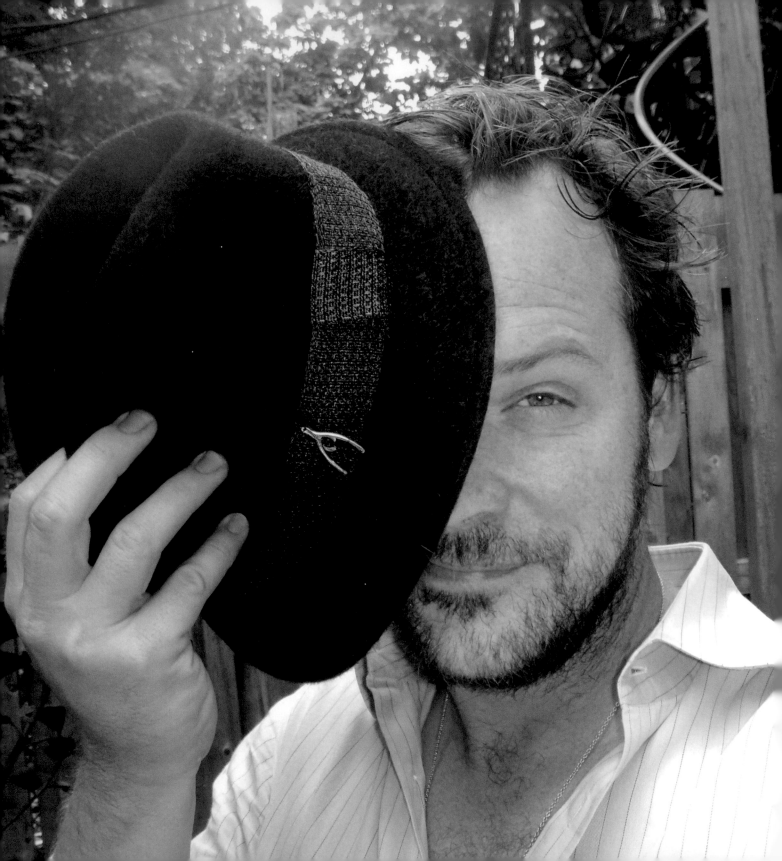

I have a lot of ideas.

Peter Sarsgaard

I exist and I am vital.

Elijah Wood

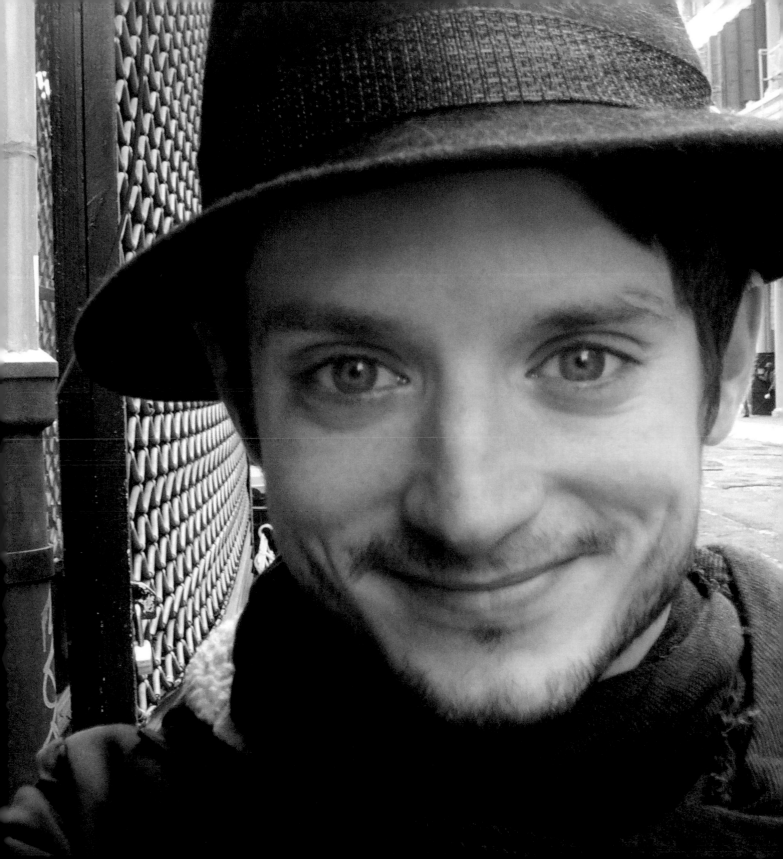

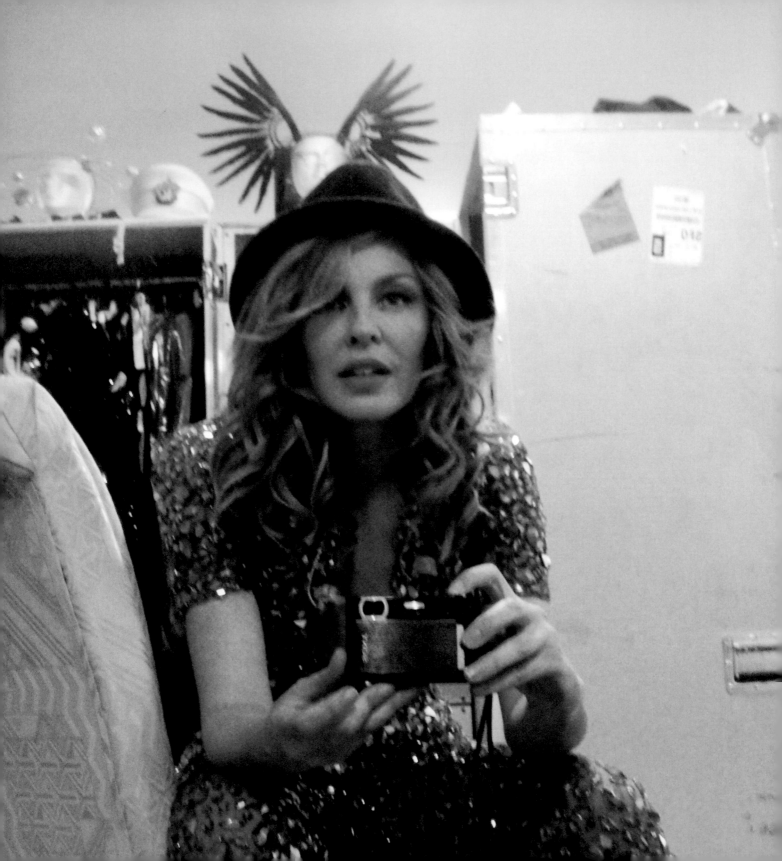

I can still hear you, even though the show has finished. Can you hear me?

Kylie Minogue

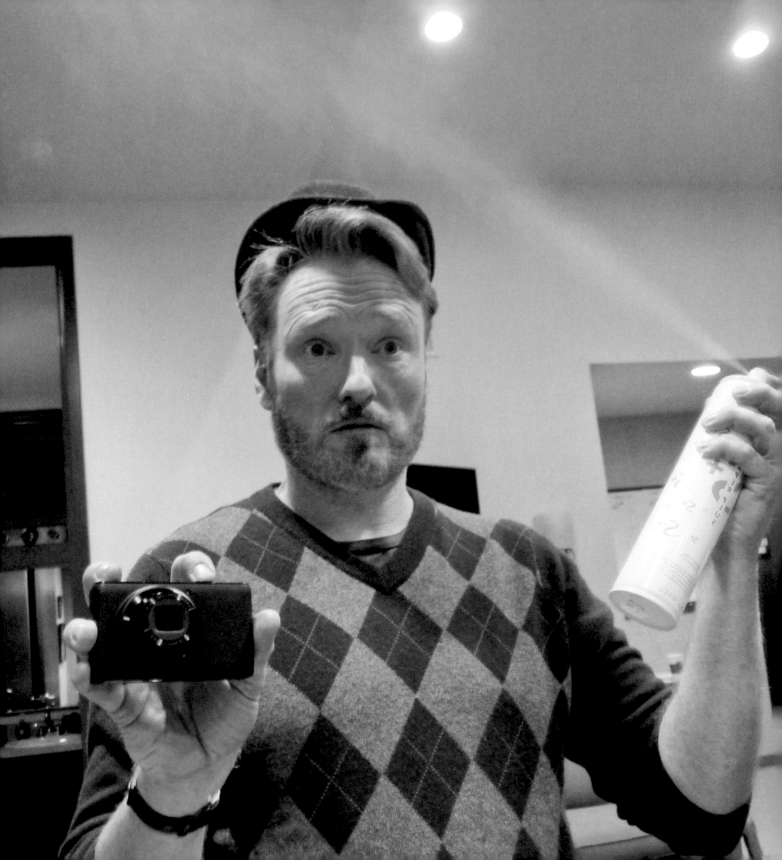

More hair spray, damn it!

Conan O'Brien

A bowl for my brain soup.

Ashton Kutcher

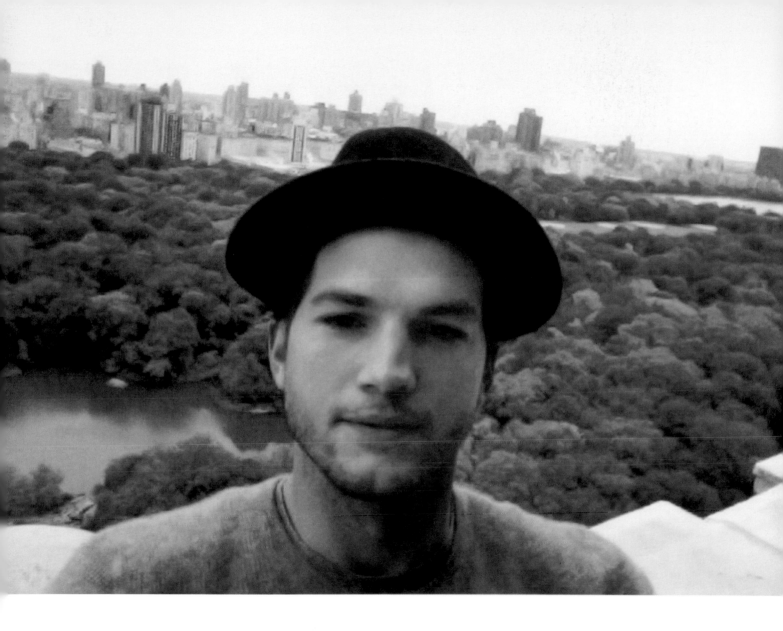

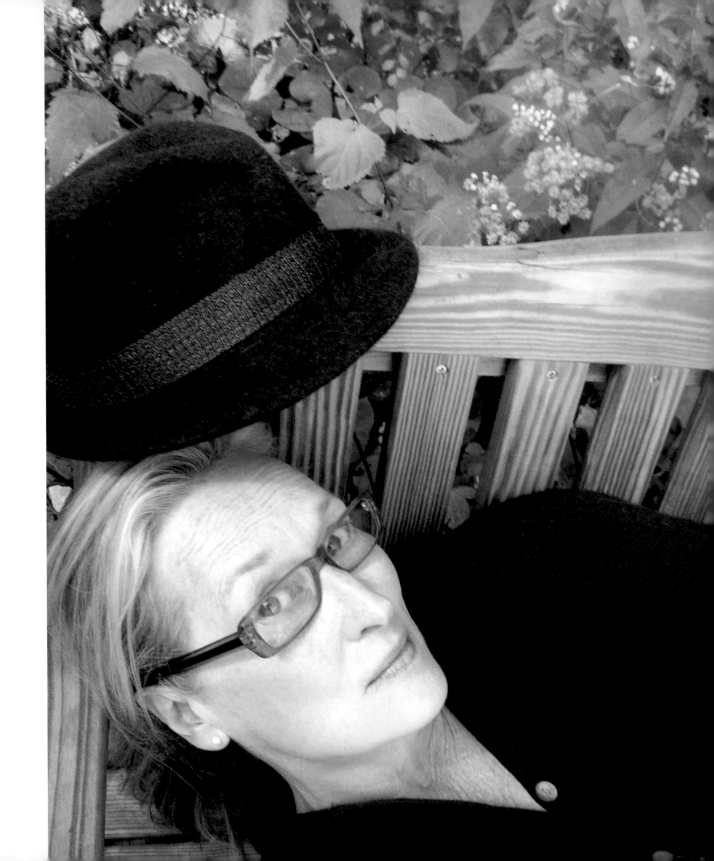

A hat is a hat, 'til it's on your head;
then it becomes you:
it is how you're read.

Meryl Streep

Here's your hat, what's your hurry?

Edward F. Burns

I have special powers!

Steven Soderbergh

I hate quotations.
Tell me what you know.

(Ralph Waldo Emerson)

Ben Stiller

Love one another . . .

Reese Witherspoon

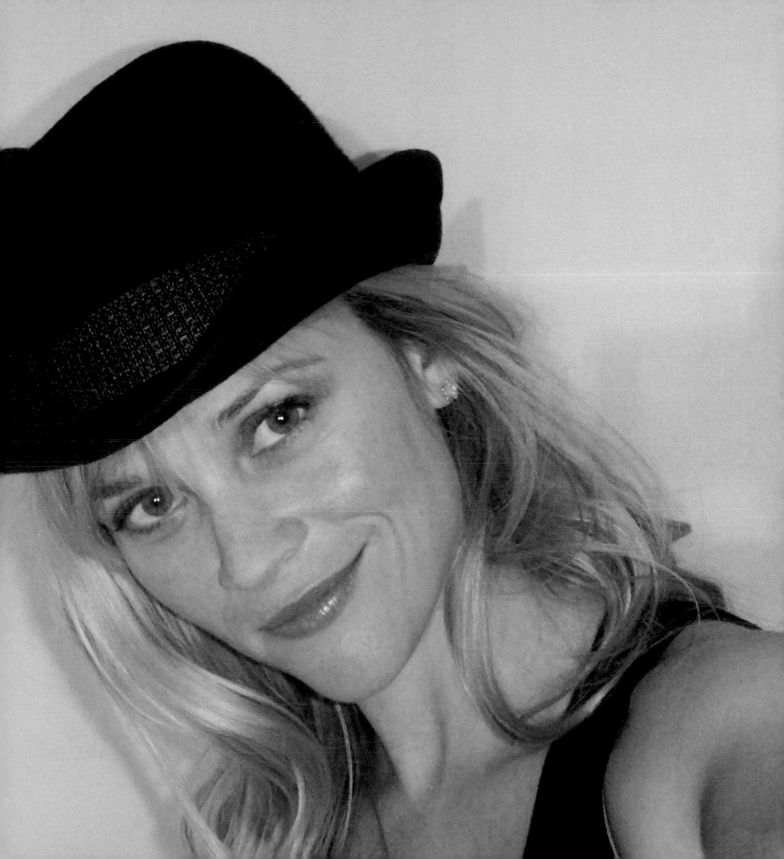

Eat vegetables.

Tim Robbins

Angelina Jolie

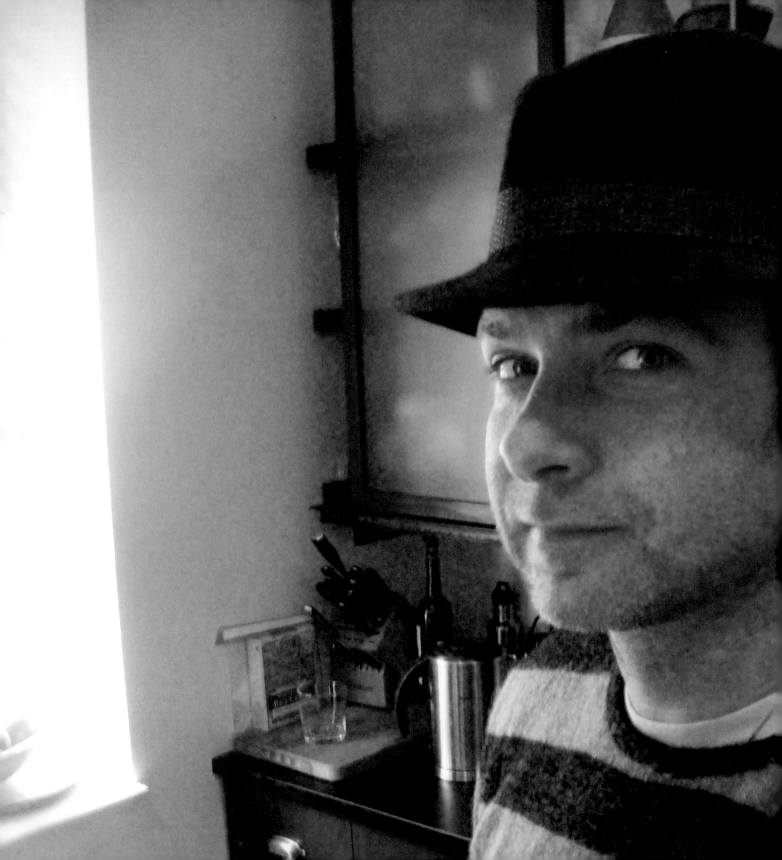

If the hat fits, wear it.

Liev Schreiber

In life, try on as many hats as you can. You might find that one actually fits.

Justin Timberlake

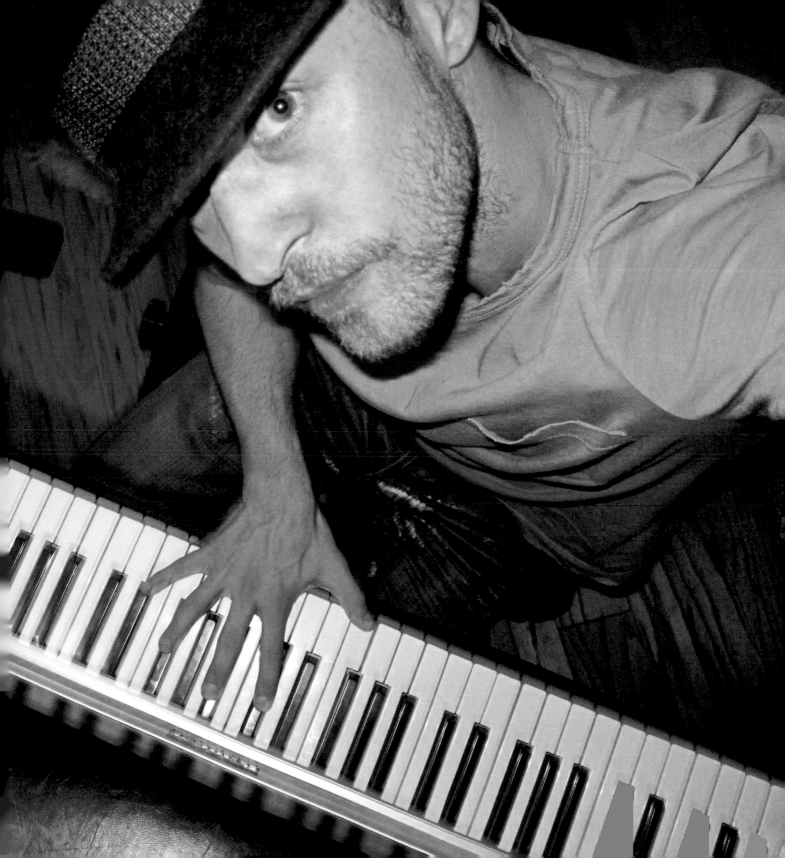

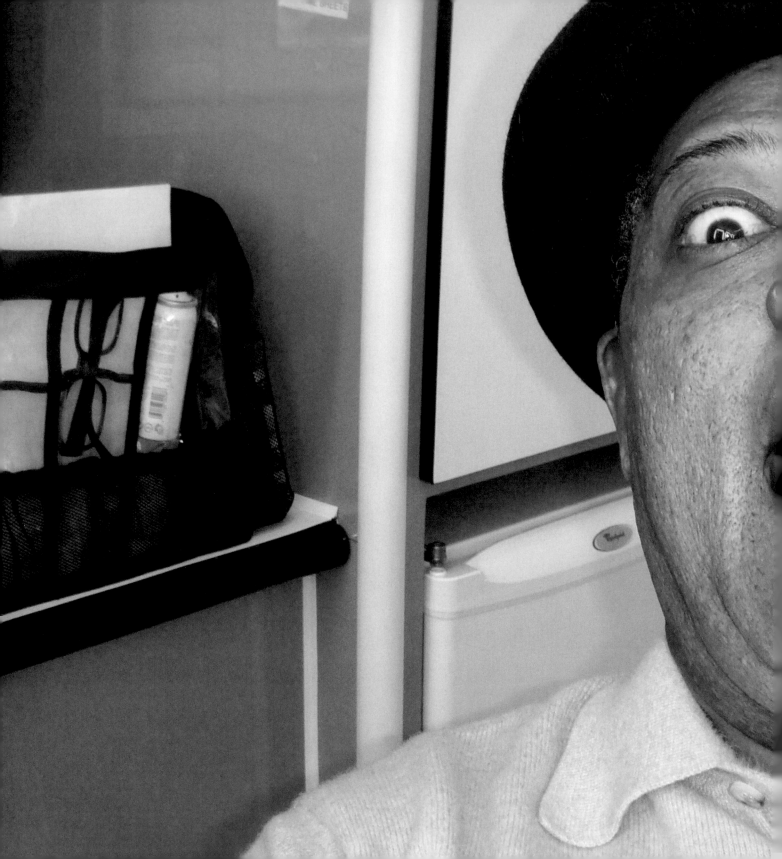

Wow!
I didn't expect to see you!

Laurence Fishburne

I can't really understand why
everyone is so attracted to me . . .

Peter Lindbergh

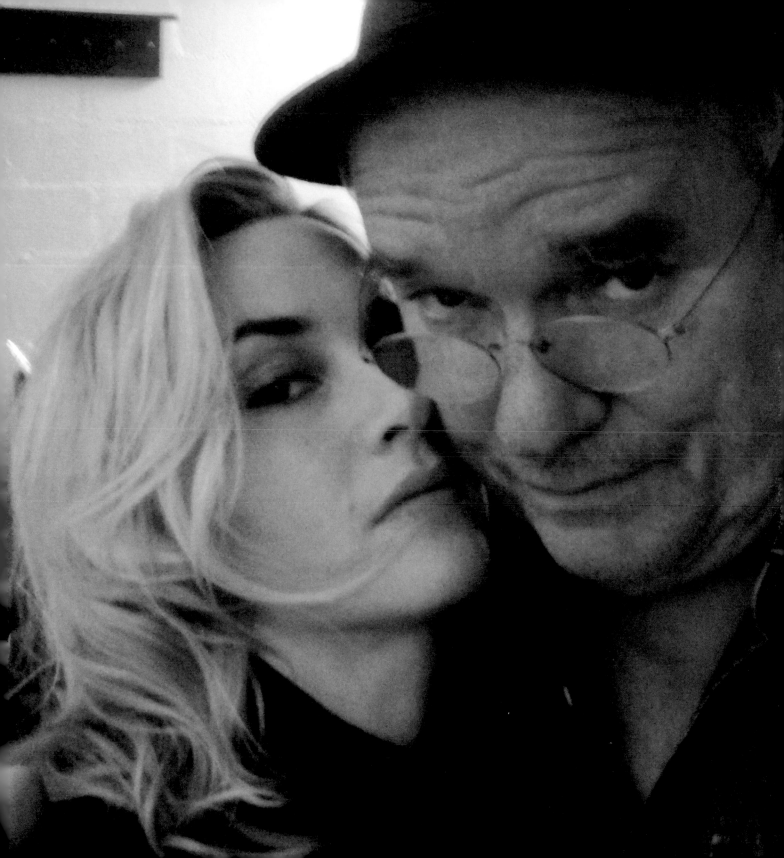

I cannot think of a quote off the top of my head.

Stephen Daldry

Does this hat make me look fat?

Cynthia Nixon

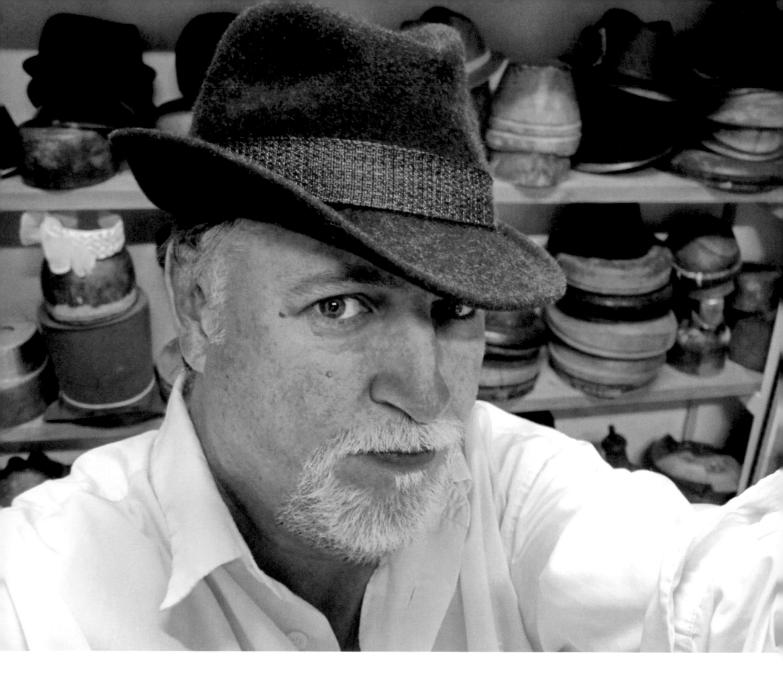

I understand;
don't give up on me.

Albertus Swanepoel

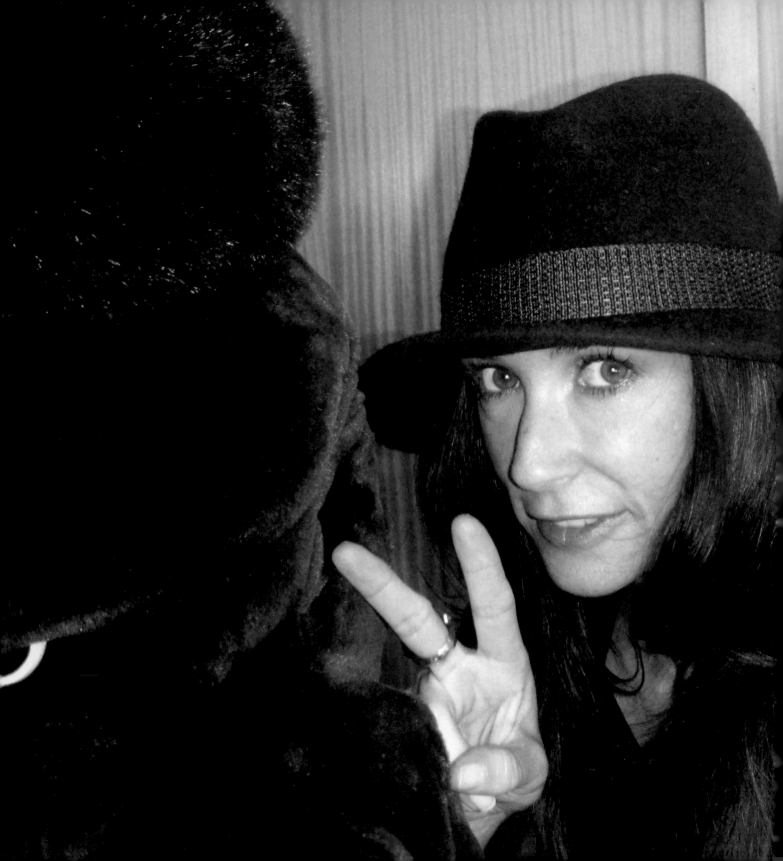

*2gether anything
is possible!*

Demi Moore

*I am like you; don't be afraid
and look me in the eyes.*

Javier Bardem

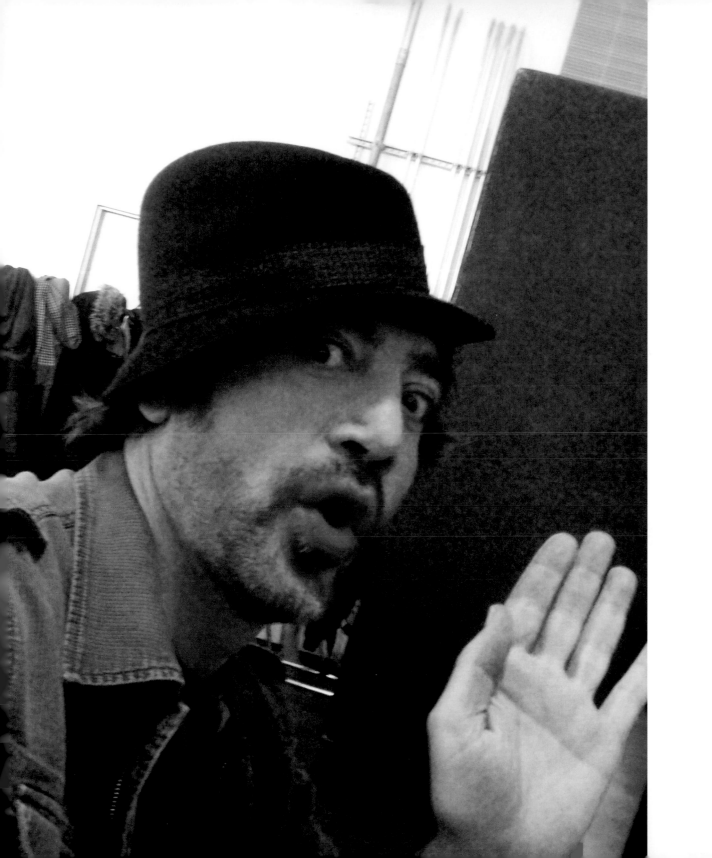

Que la fête commence.

Vanessa Paradis

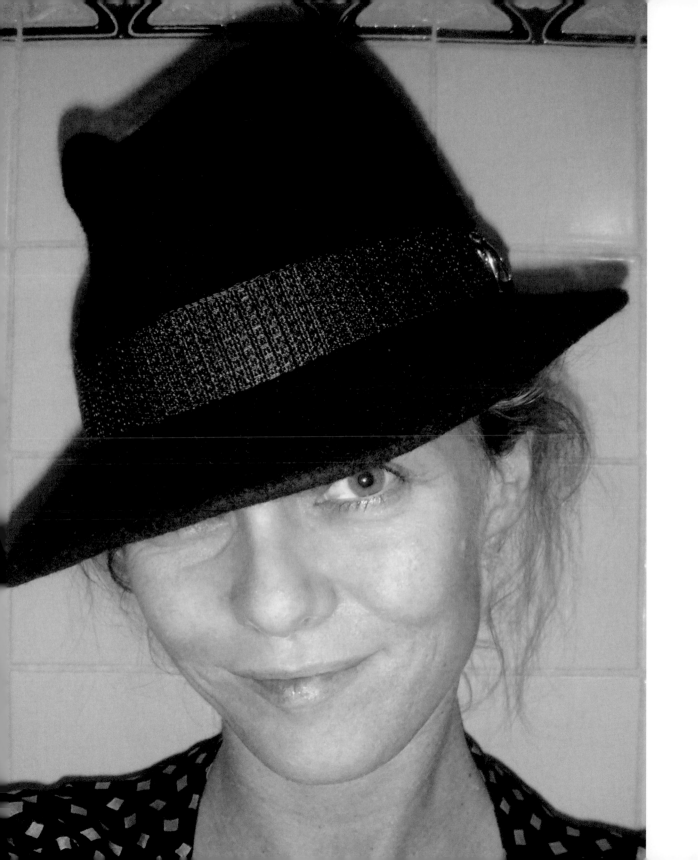

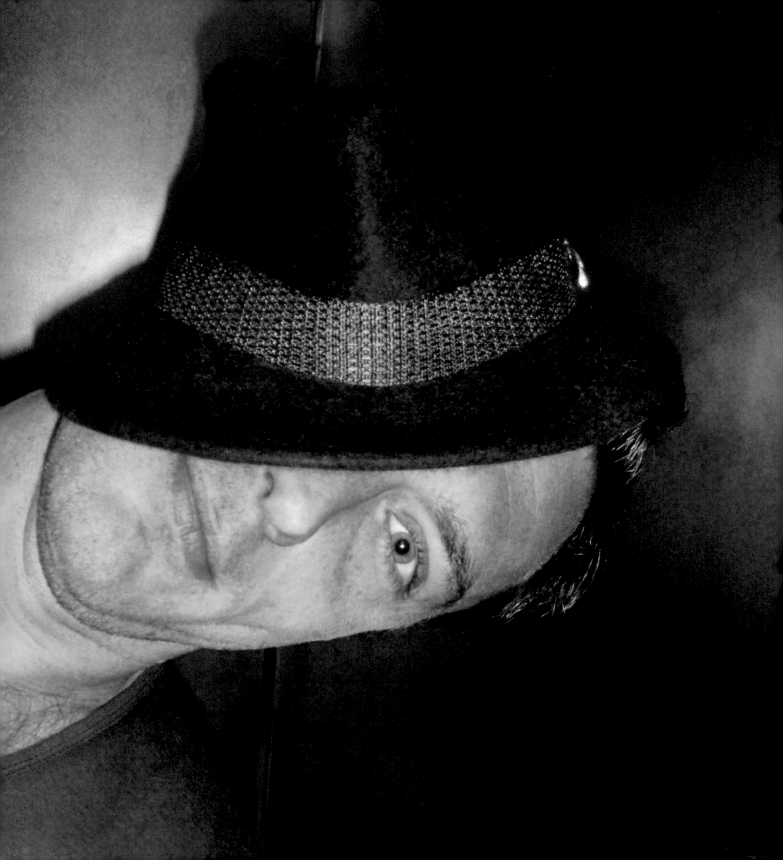

What a wonderful world.

Jude Law

*The most important
relationship is the one
you have with yourself.*

Diane von Furstenberg

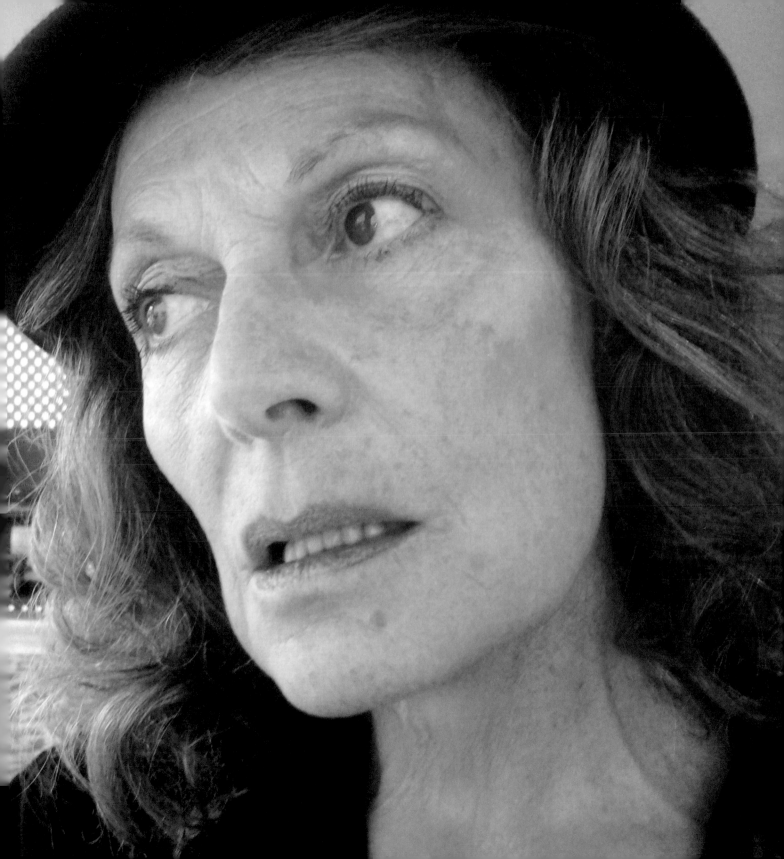

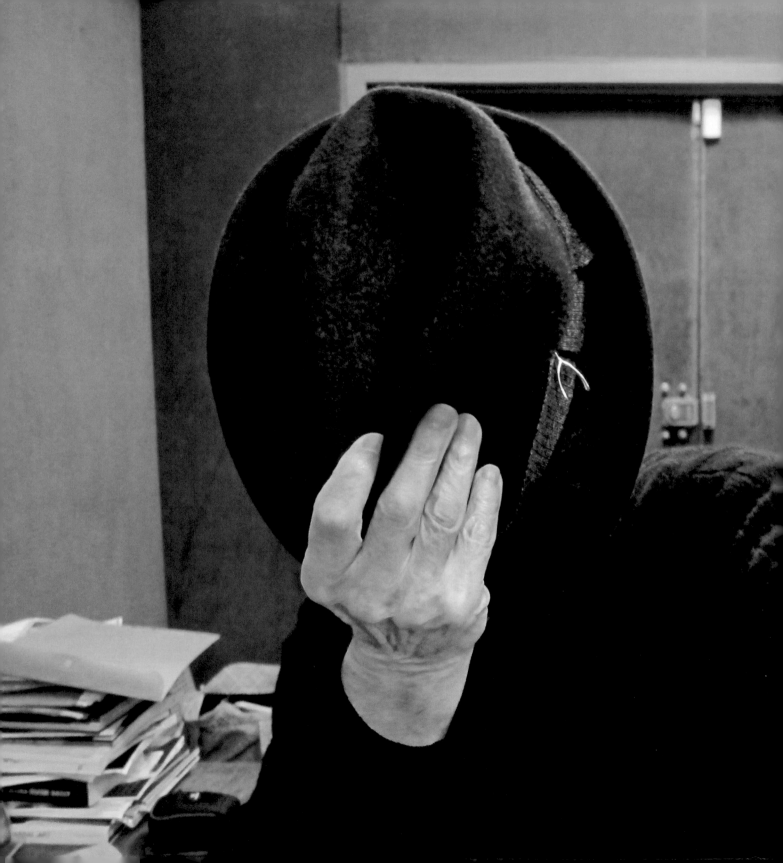

Get off my property.

Woody Allen

Daria Werbowy

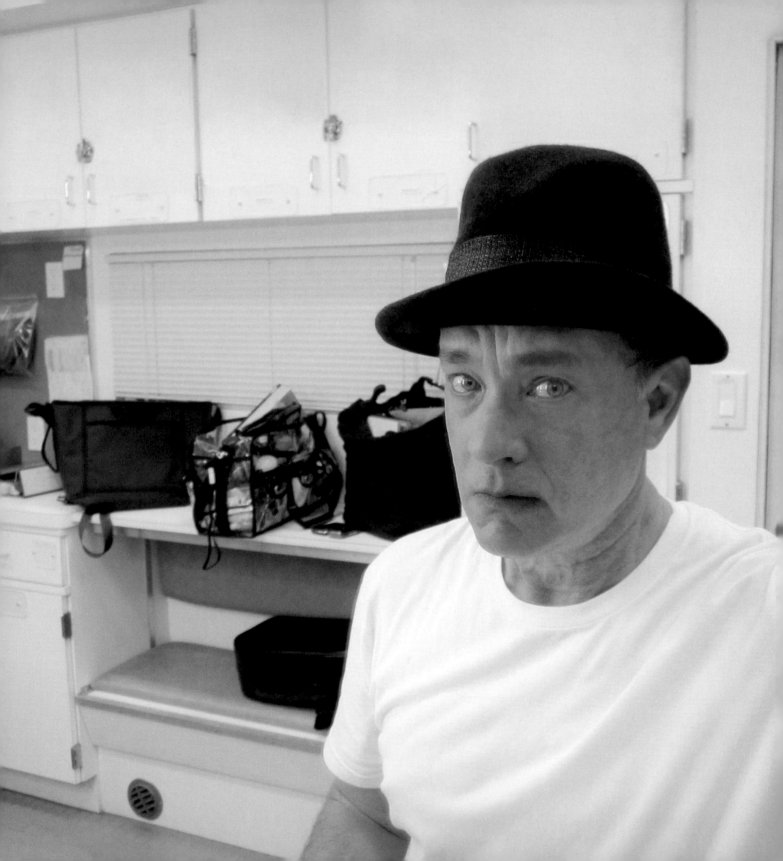

Hats make the man.

Tom Hanks

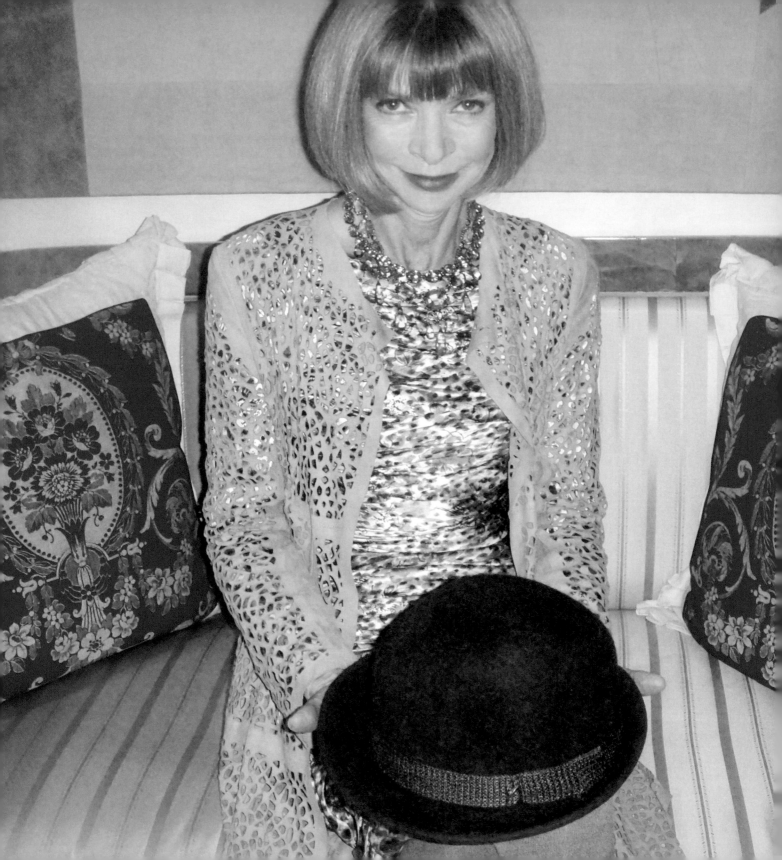

*Does it come in any
other color?!*

Anna Wintour

Finally!!!

Leonardo DiCaprio

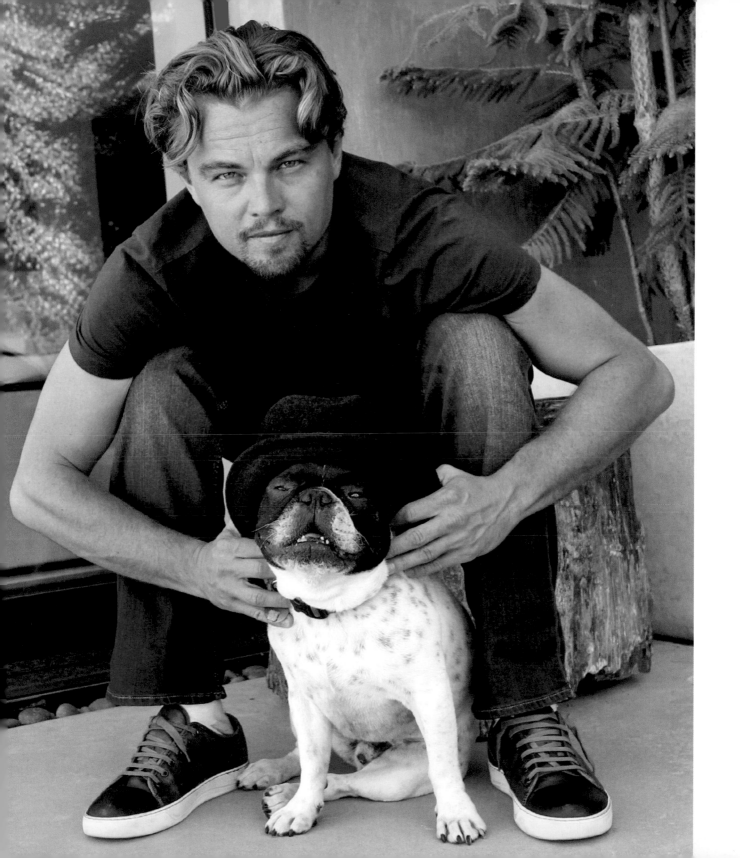

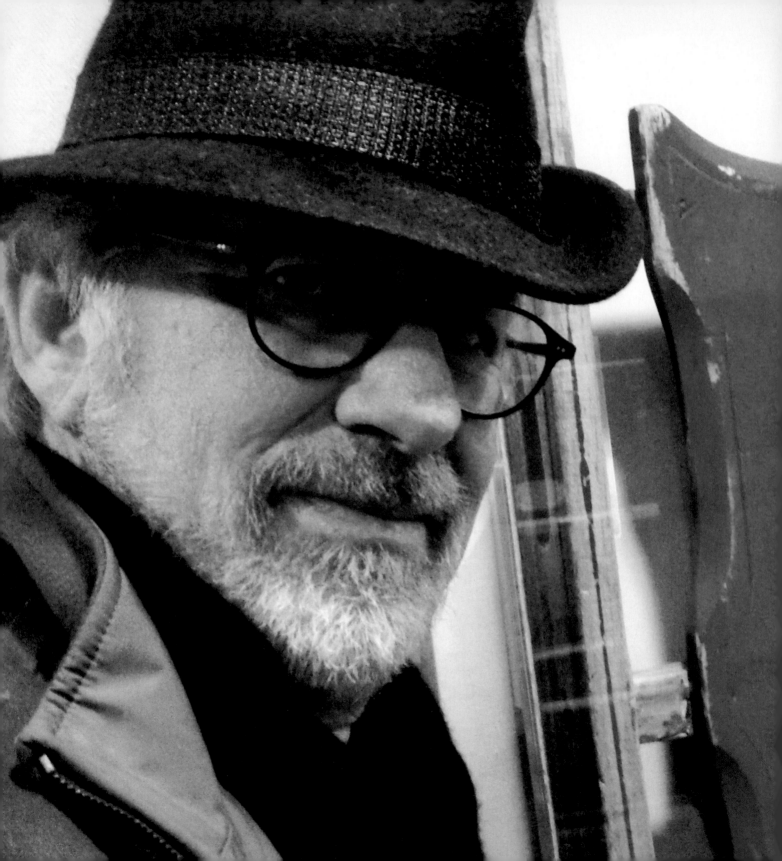

Let it snow!
Let it snow!
Let it snow!

Steven Spielberg

I am Me.

Let me tell you what I see.

Anne Hathaway

Daniel Craig

Knock, knock . . . who's there?

Ethan Hawke

I'm wearing this hat today.

Christy Turlington

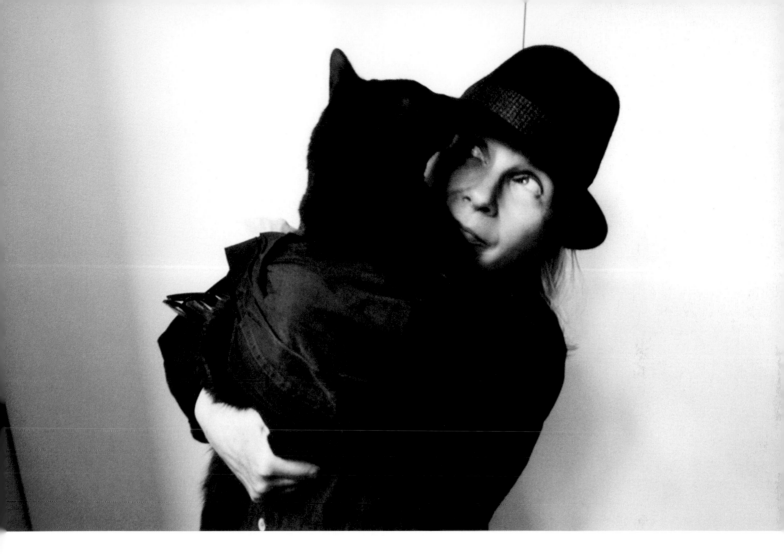

Be kind.

Brigitte Lacombe

Happy to be alive!

Stephen Dorff

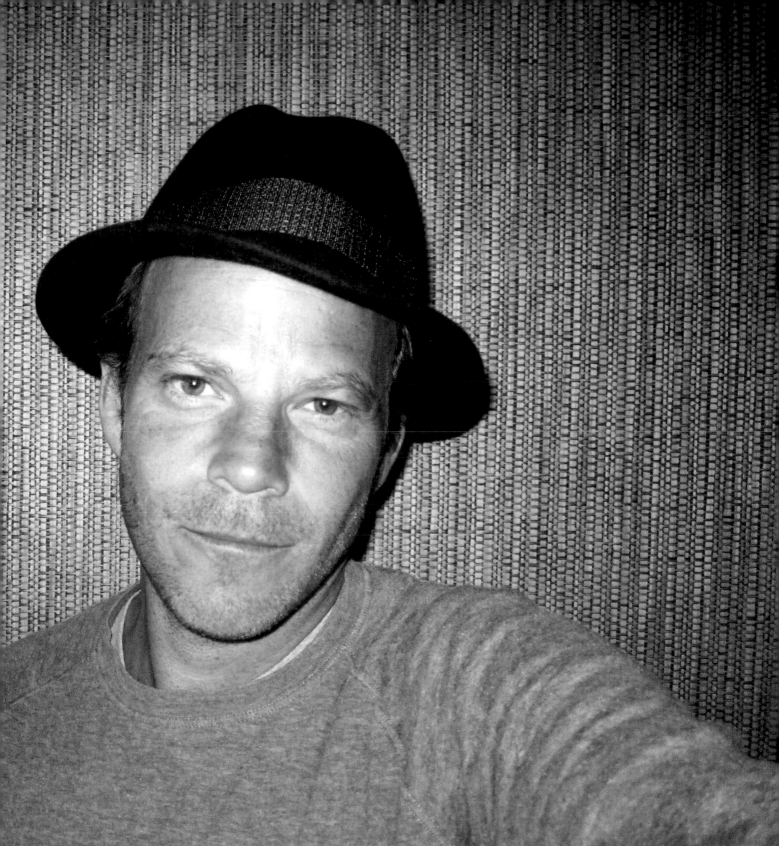

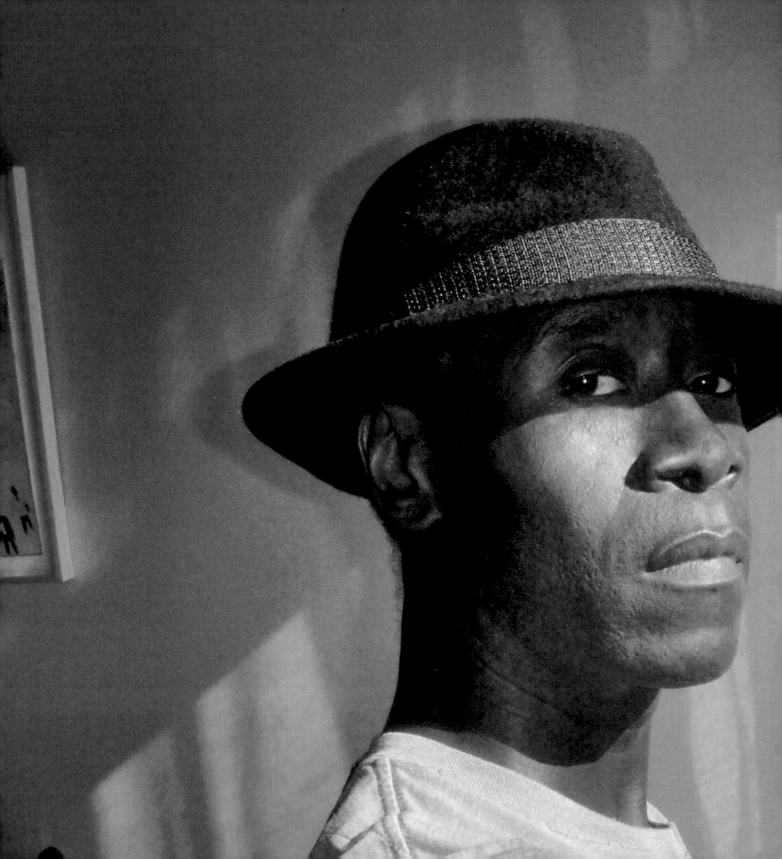

I'm more than just a pretty face!

Don Cheadle

Good luck getting me to shut up now.

Daniel Radcliffe

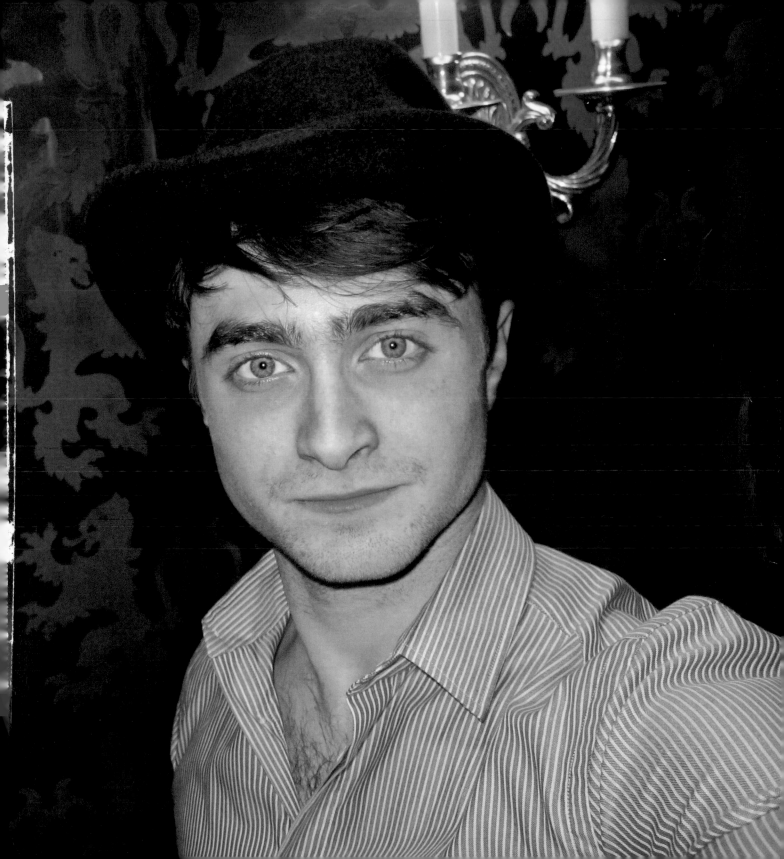

Listen to me.

Natalie Portman

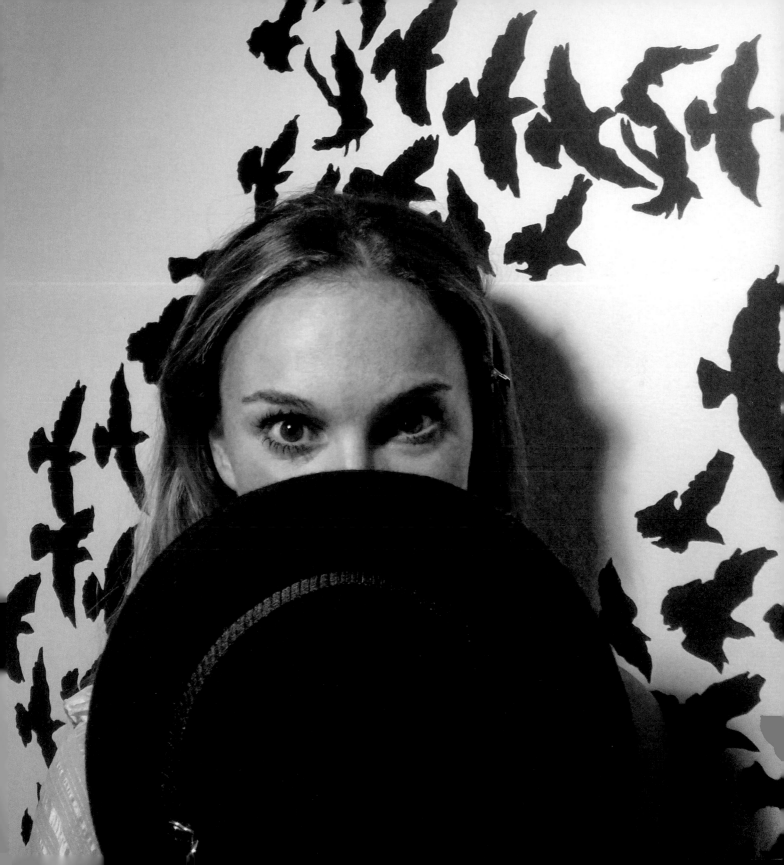

Matt Damon

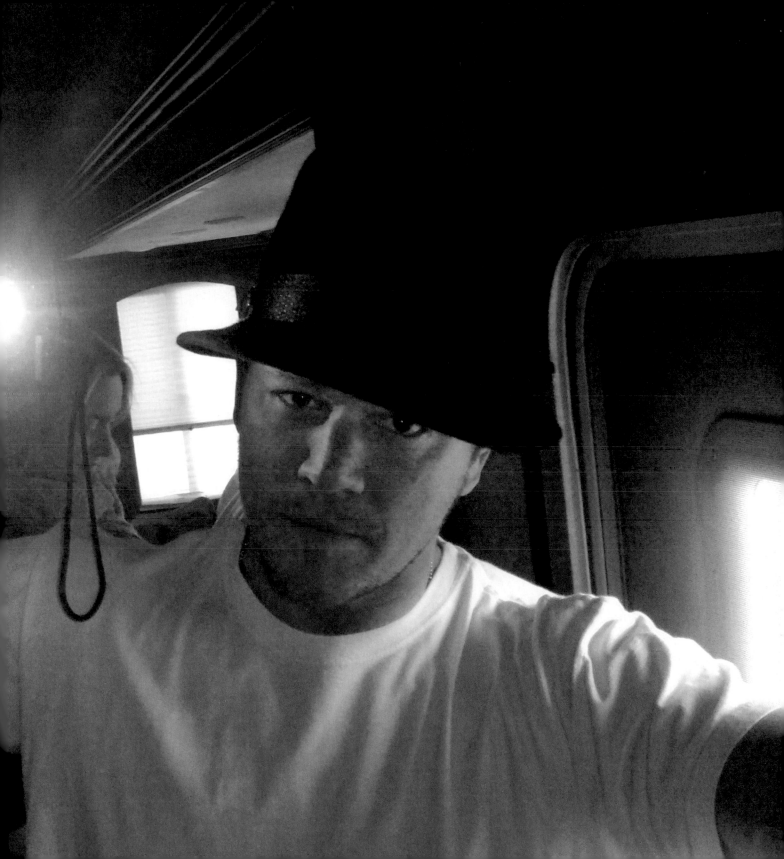

Moody, even with a hat.

Mario Cantone

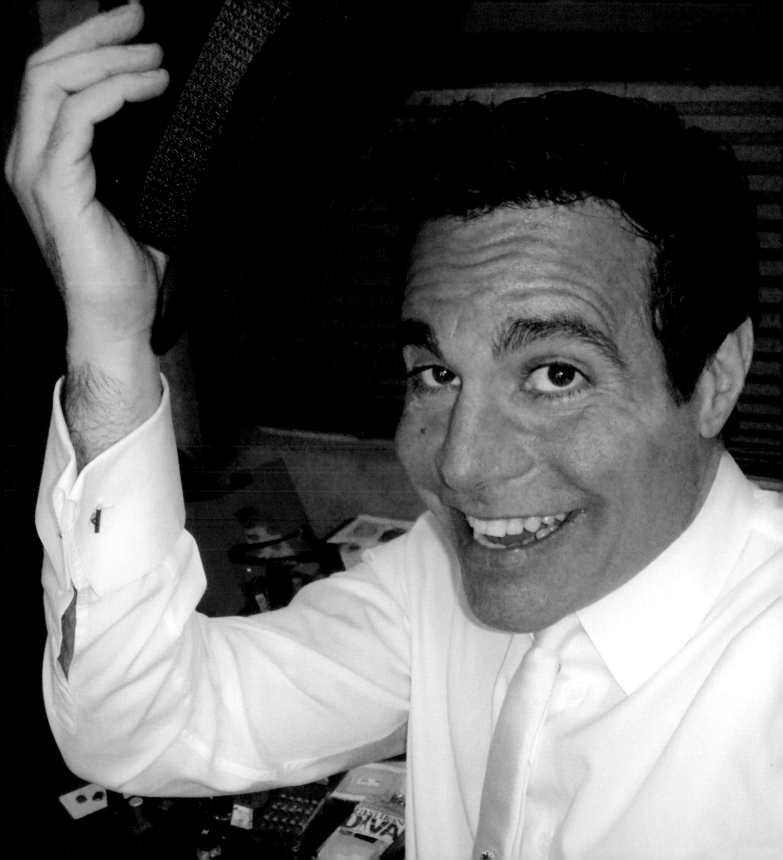

Hi, I love you.

Julia Roberts

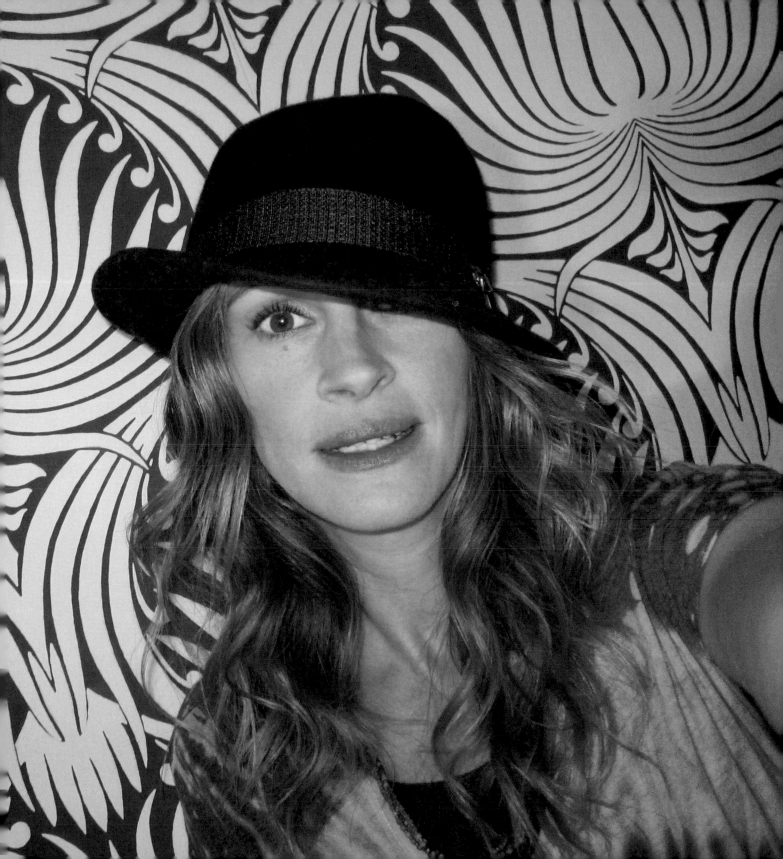

*I will always be
here for you.*

Maria Sharapova

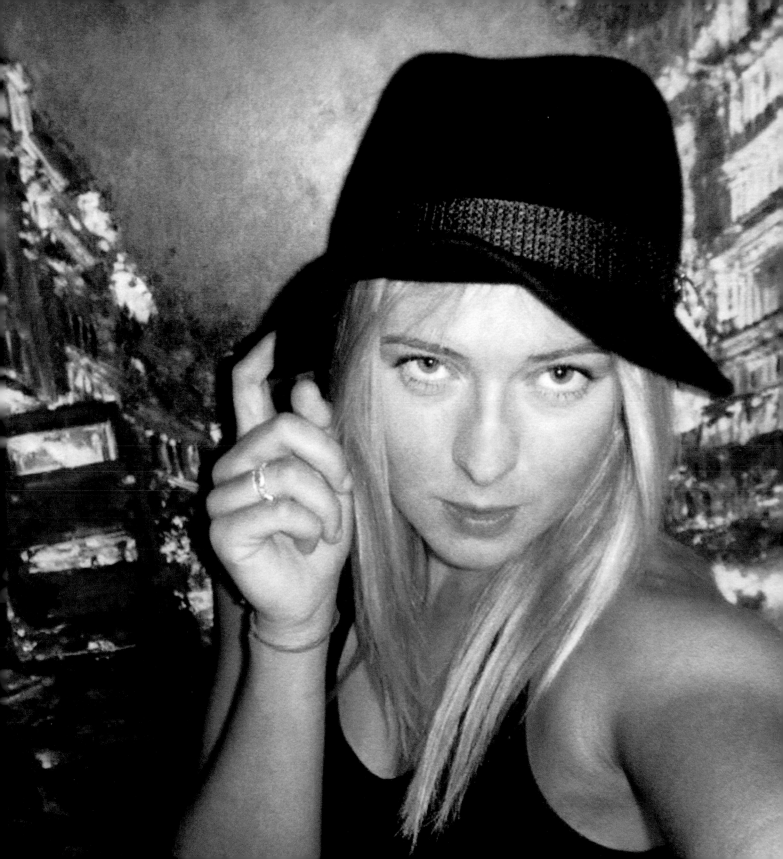

I'll be okay.

Kevin Bacon

Mmmmwa! I've missed you!

Kyra Sedgwick

See me. I see you.

Julianne Moore

Let's redefine voice and consider its strength while using it, and never misuse it.

Laura Dern

Don't give up on me.

Jodie Foster

Me and all my flying monkeys are gonna . . . again and again and again.

James Franco

Respect your elders.

Johnny Depp

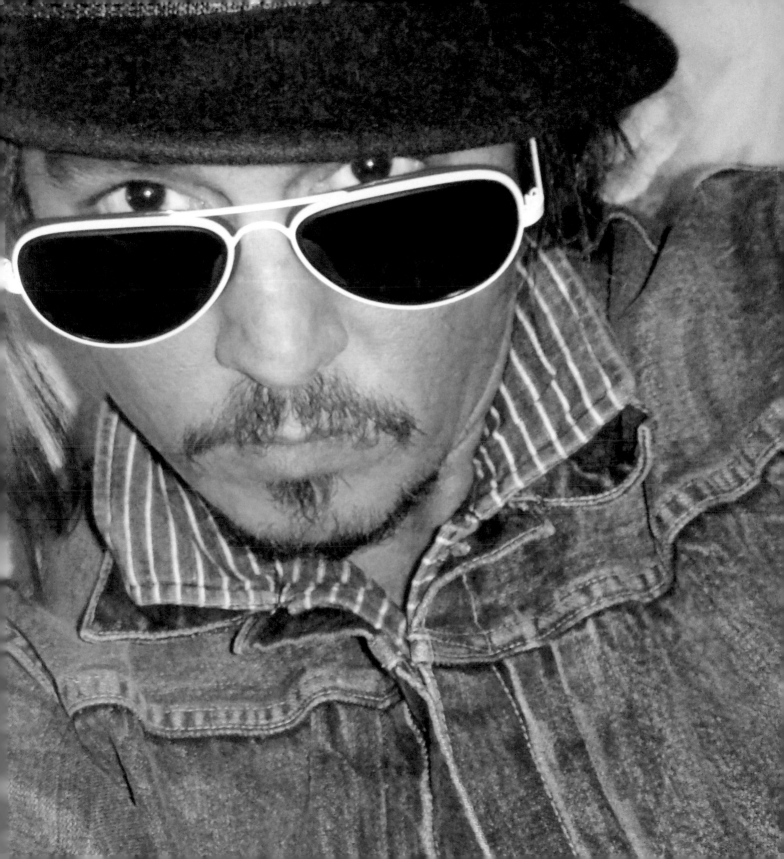

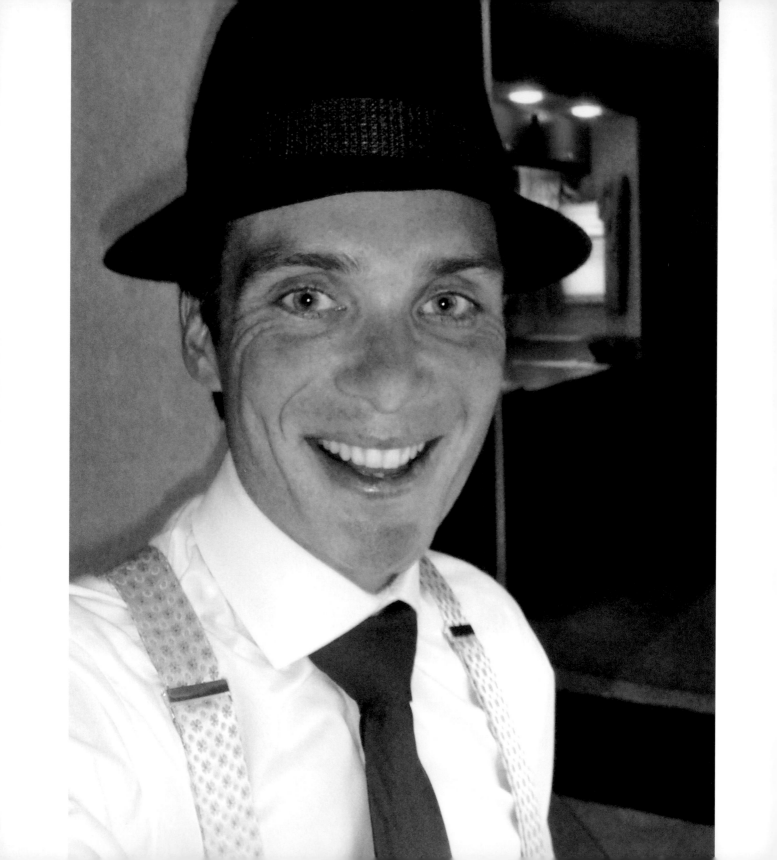

Here comes the sun.

Cillian Murphy

Good to be just another
"bozo on a bus."

Kim Cattrall

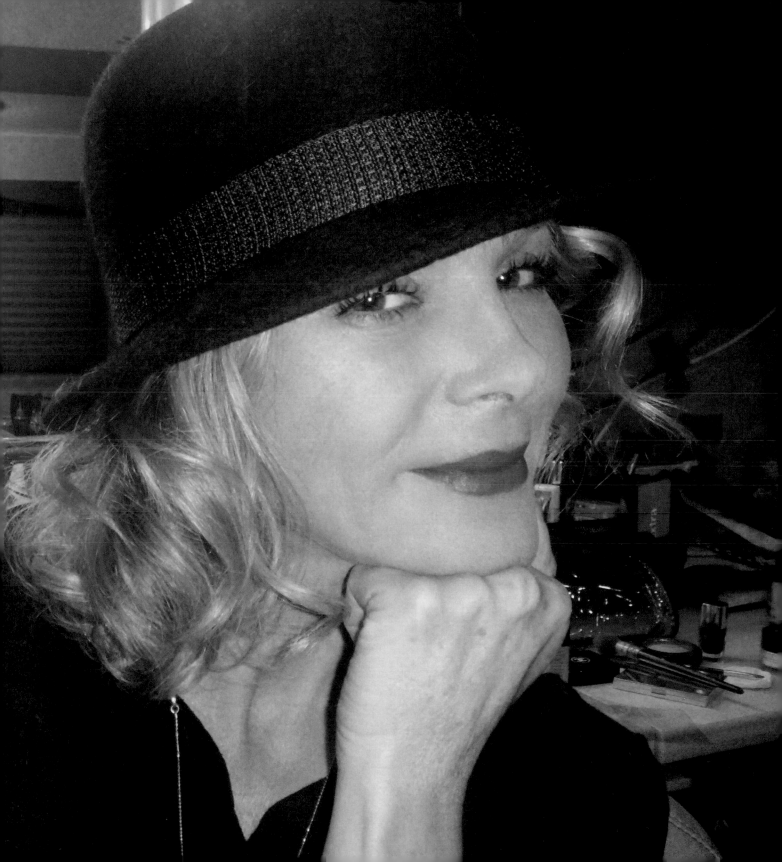

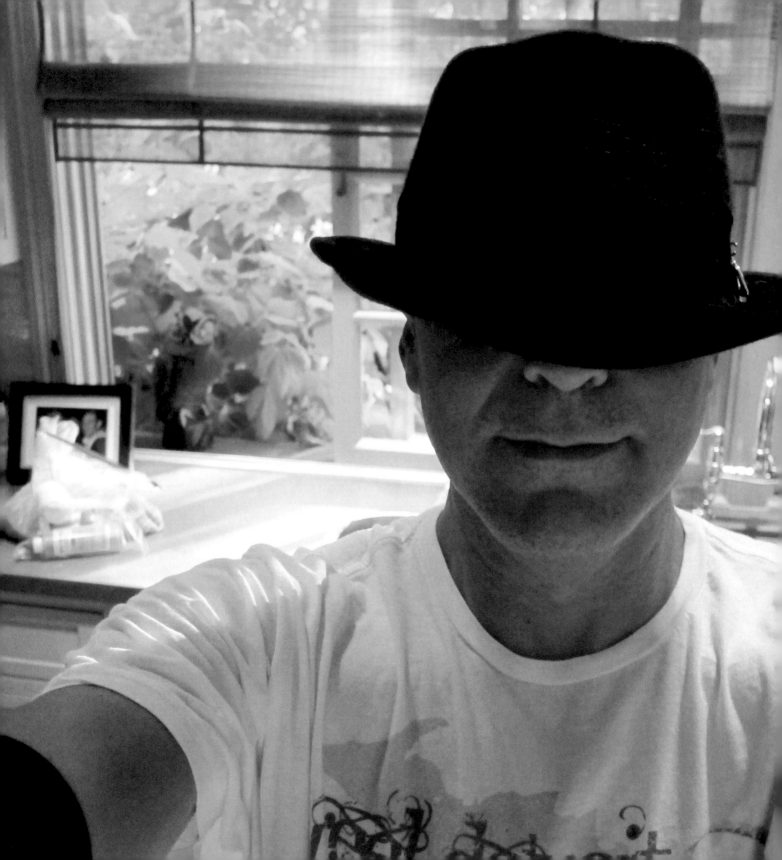

*I'm sorry about
"Batman & Robin."*

George Clooney

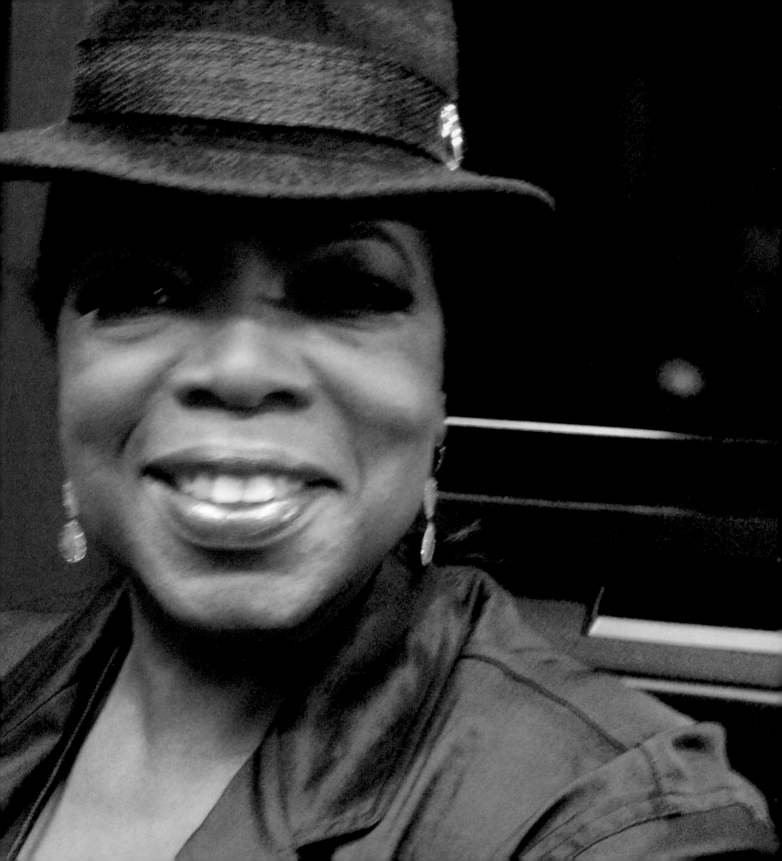

I am.

Oprah Winfrey

I want to laugh out loud, sing off-key, and tell a funny story. Don't forget I am here.

Michael Kors

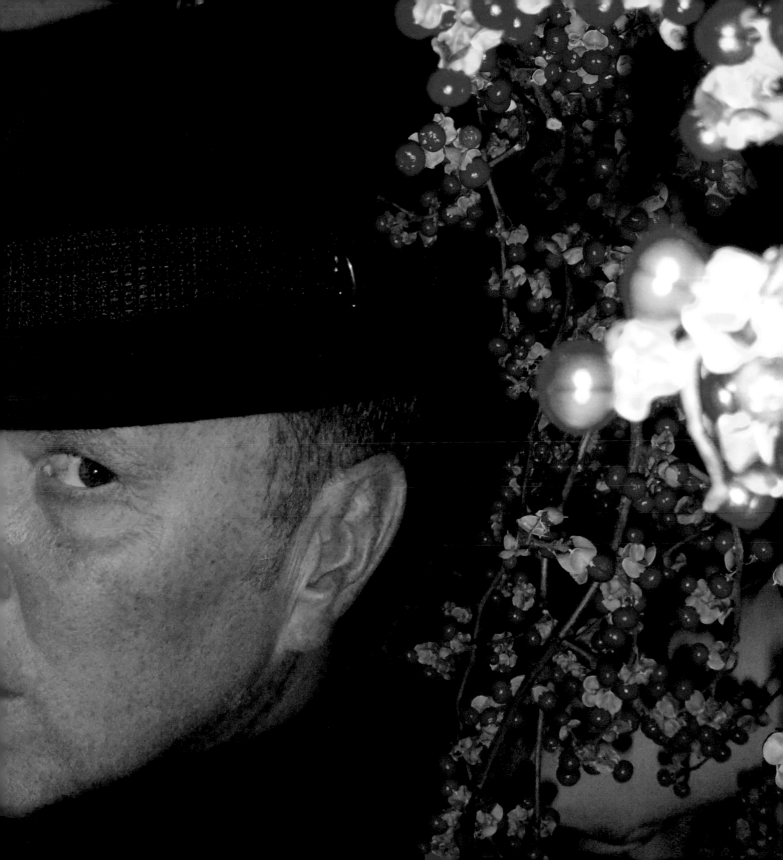

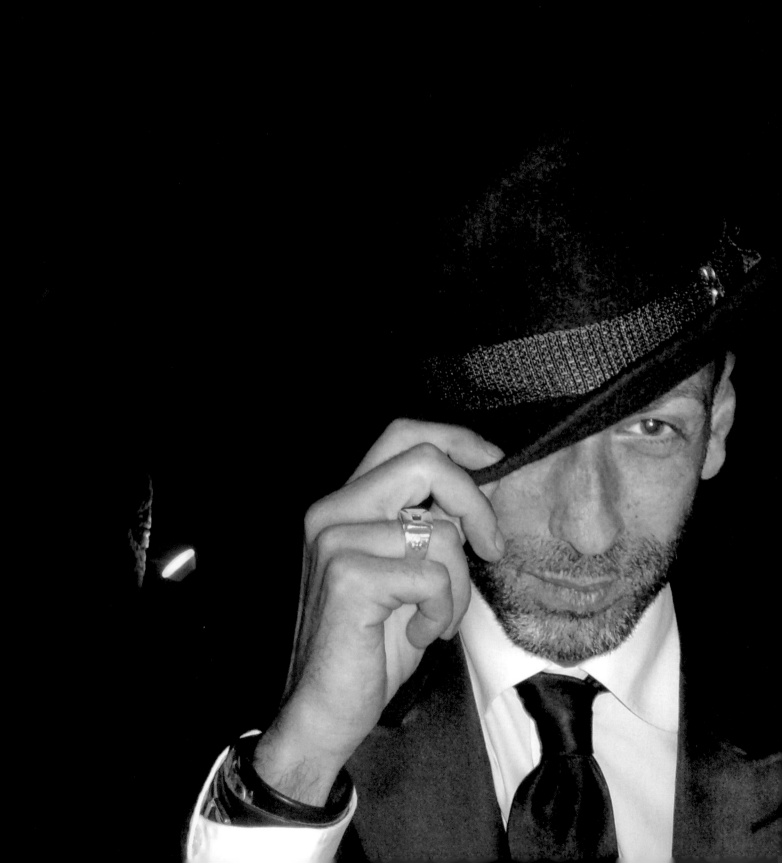

Every day I'm closer to you. And you to me.

David Souffan

Tell me a joke.

Vera Farmiga

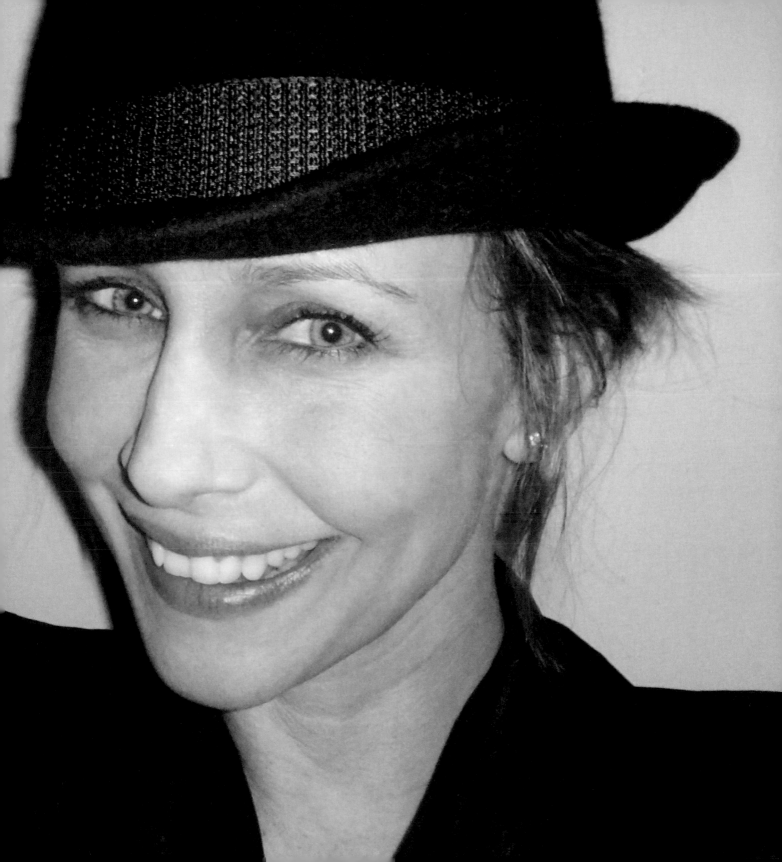

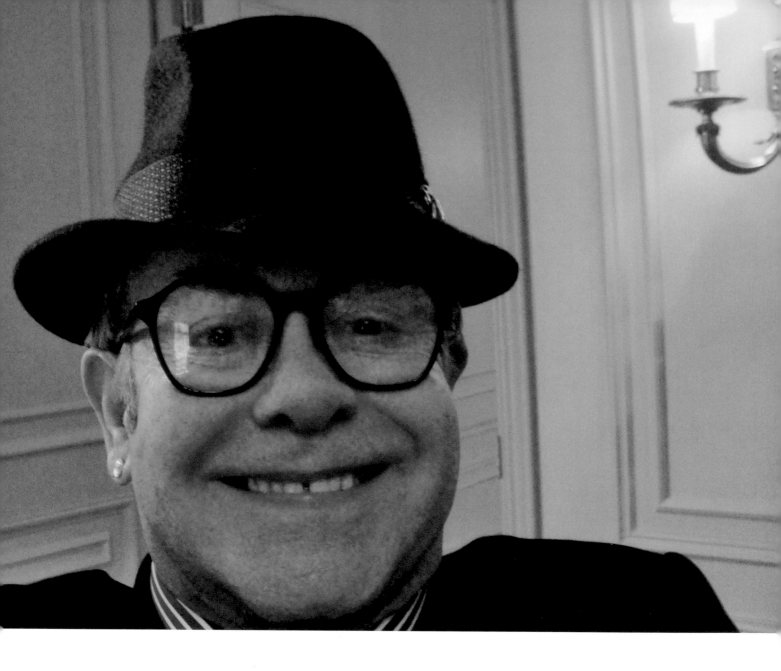

I'm nobody, but I'm alive and I matter.

Elton John

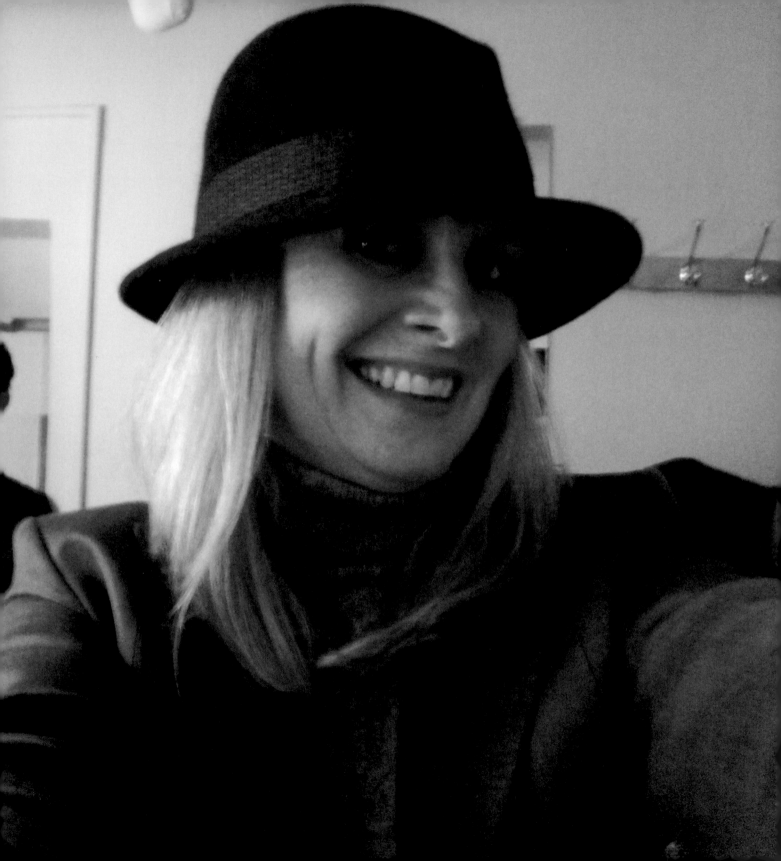

The world is beautiful;
please don't abuse it.

Twiggy

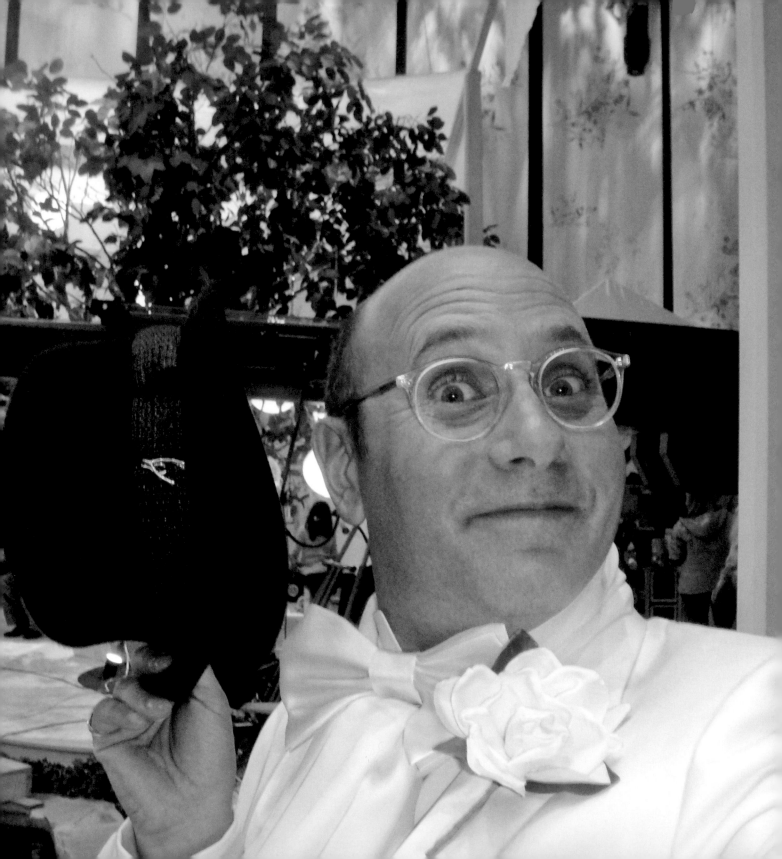

Hats off to all kids finding their voice.

Willie Garson

I am Rosie O'Donnell, star of "The Flintstones."

Rosie O'Donnell

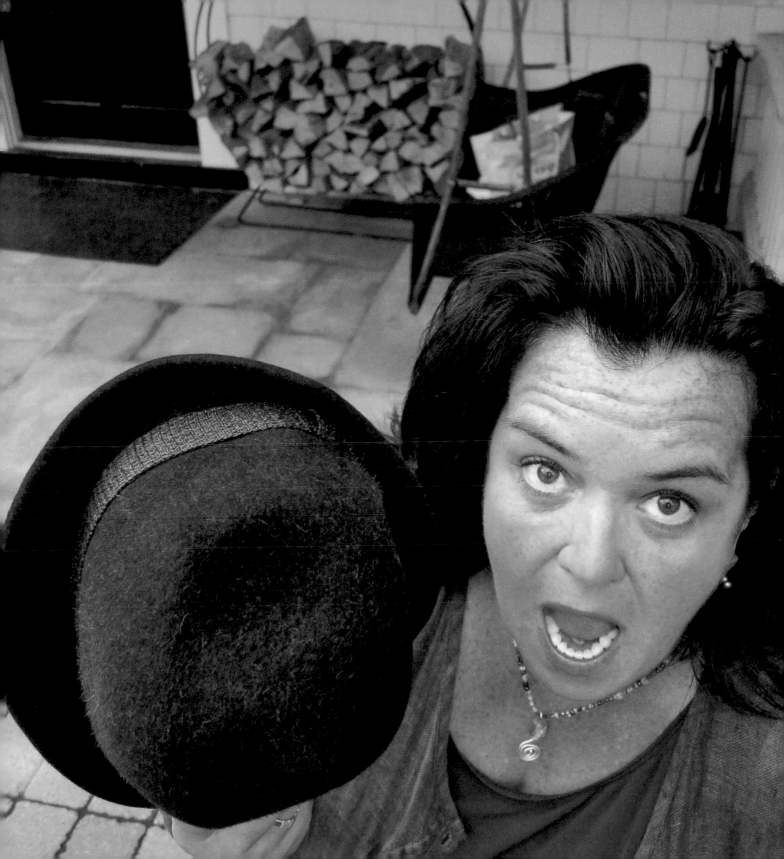

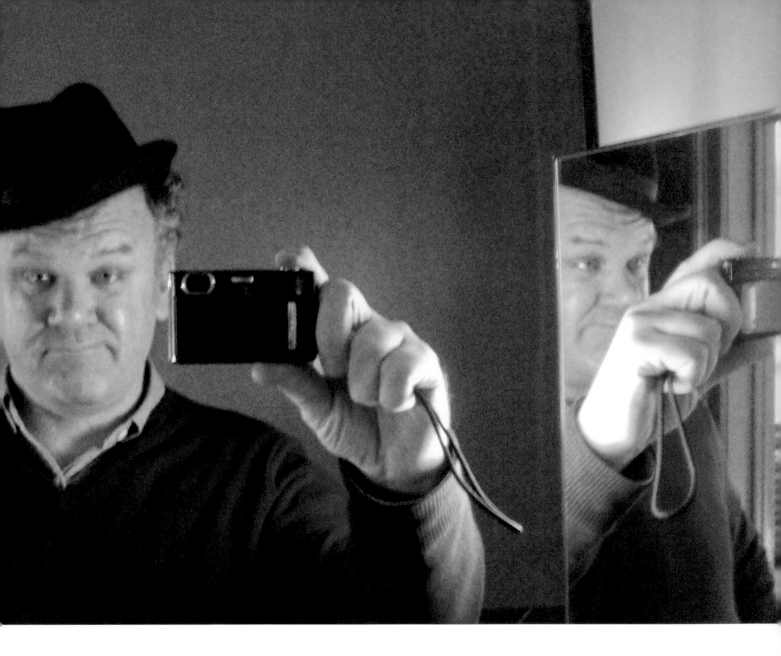

Now hear this!

John C. Reilly

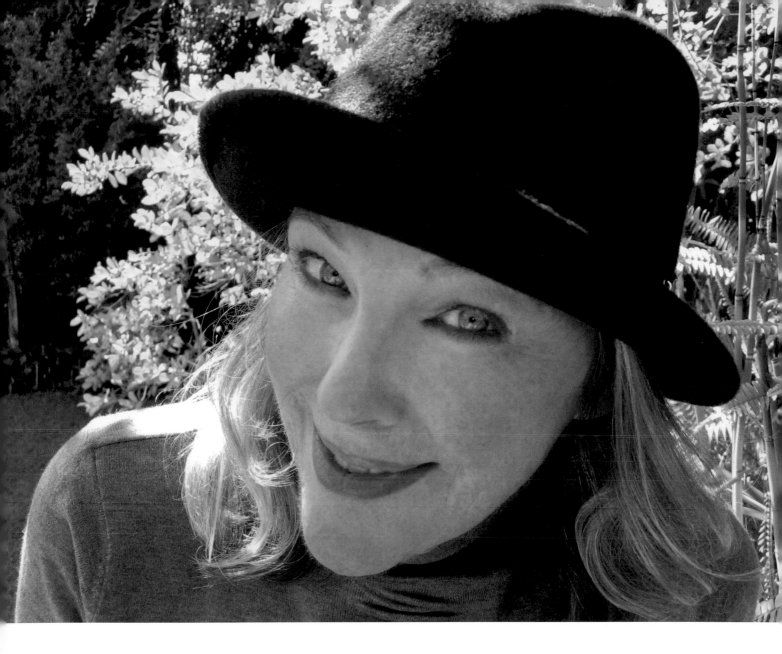

I'm laughing on the inside!

Catherine O'Hara

After you . . .

Evan Handler

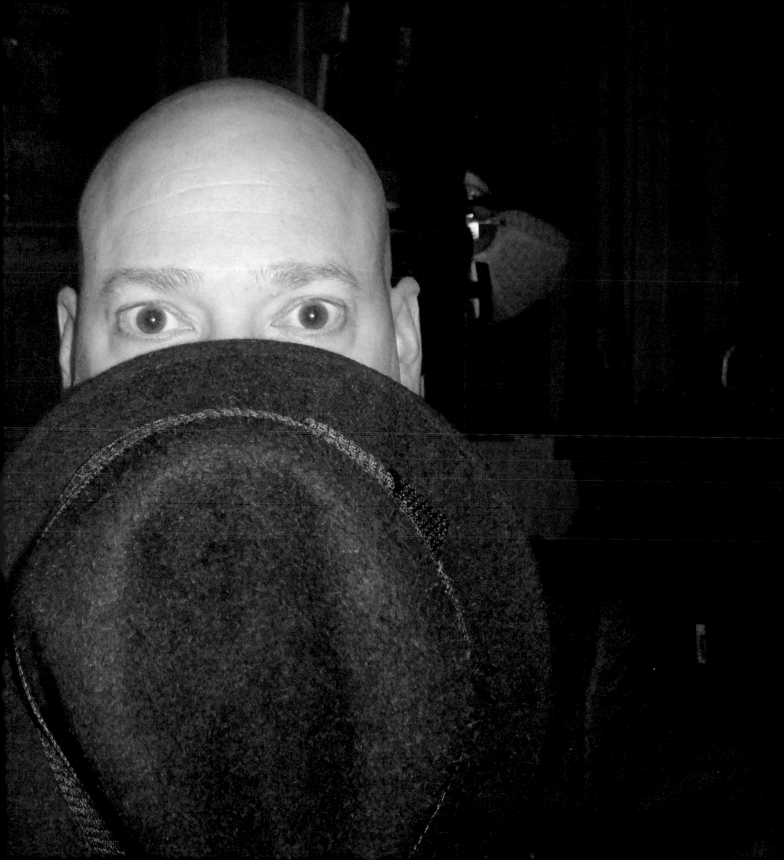

We are all equal.

Maggie Gyllenhaal

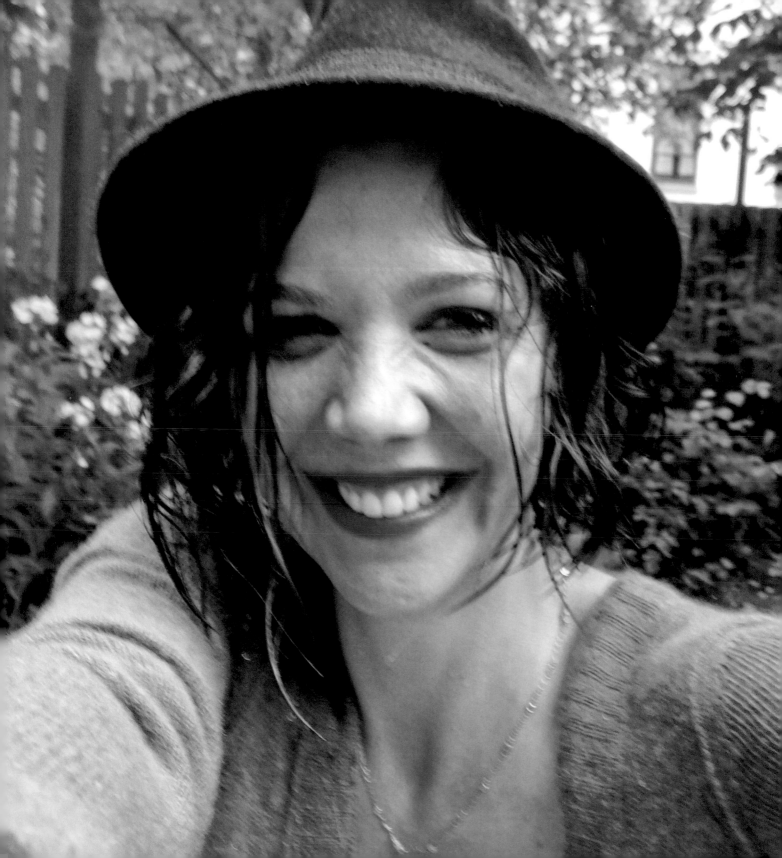

Whatever it takes.

Michael Caine

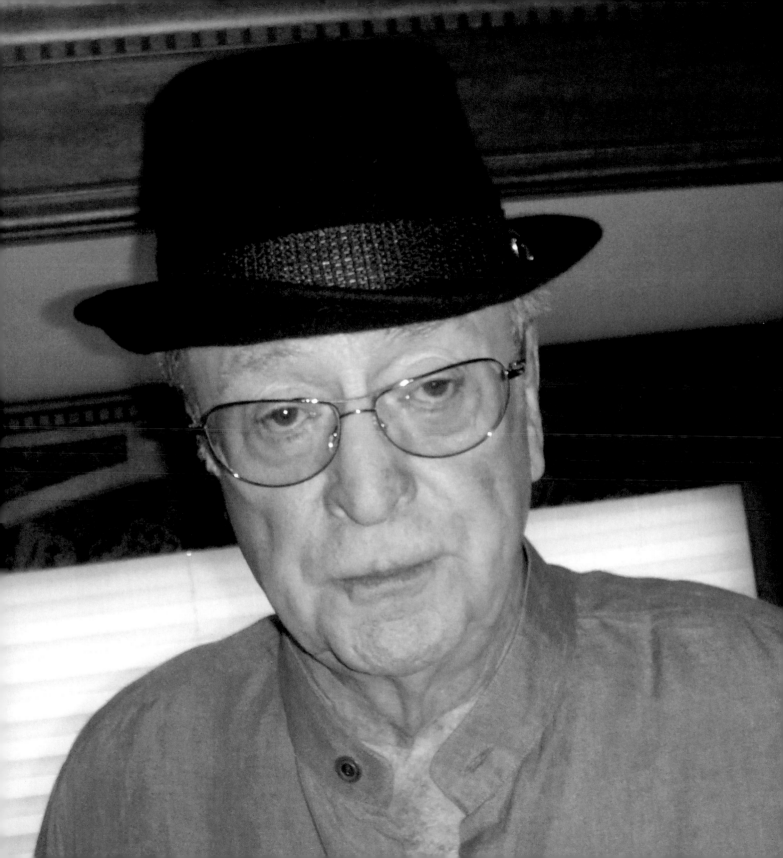

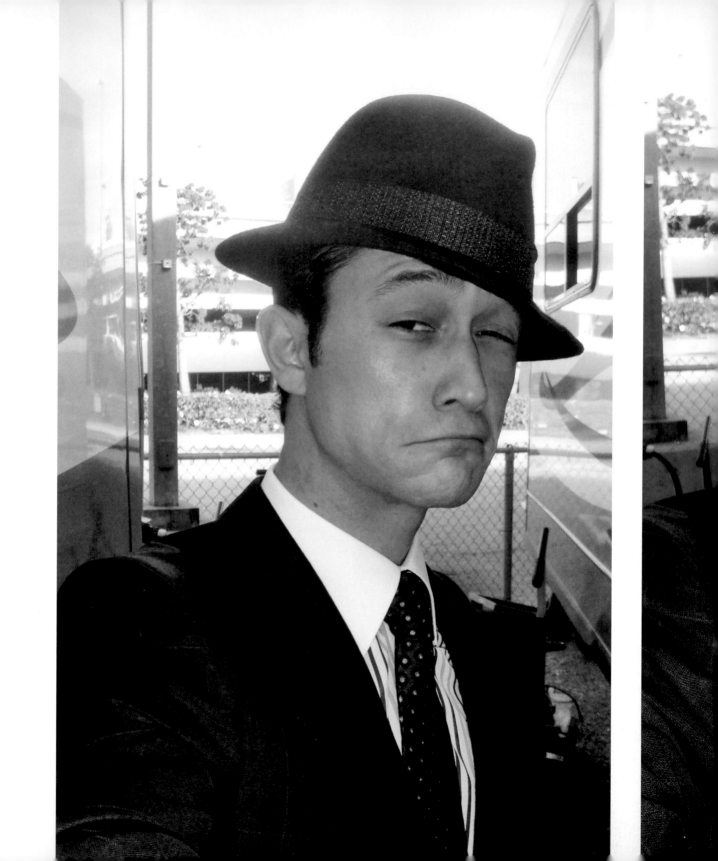

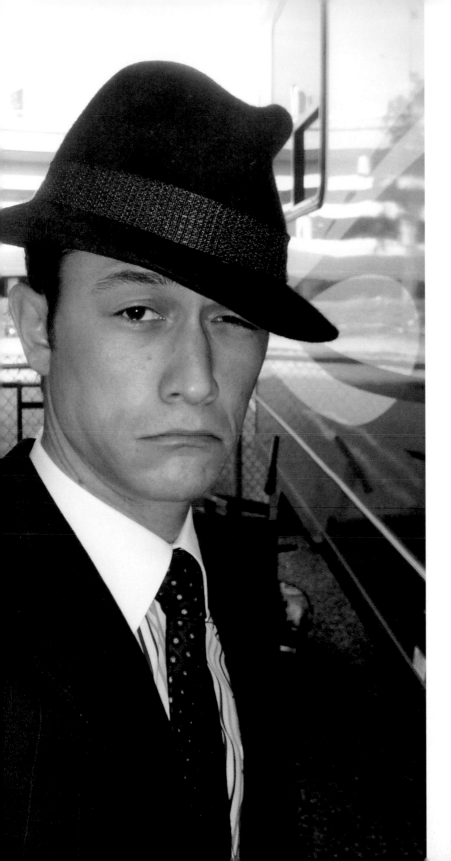

Are we recording?

Joseph Gordon-Levitt

There's nothing to fear, nothing to doubt.

Ellen Page

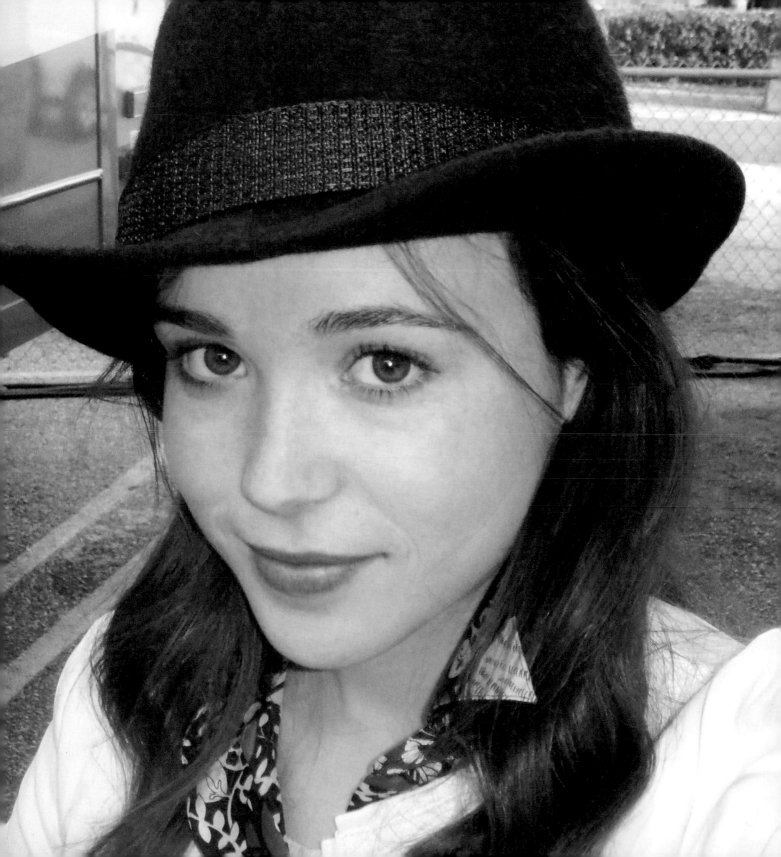

You are not scary! You look lovely.

Ang Lee

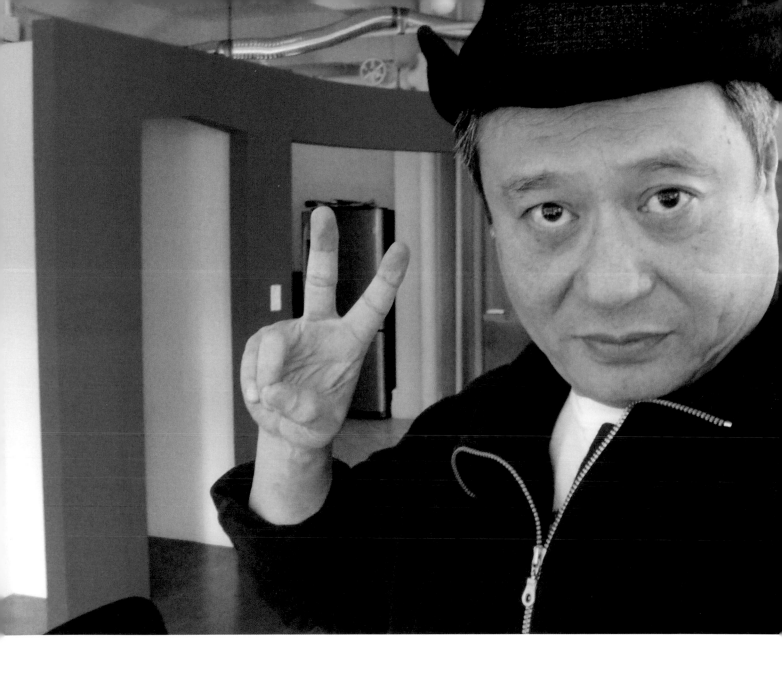

Nothing to hide!

Richard Branson

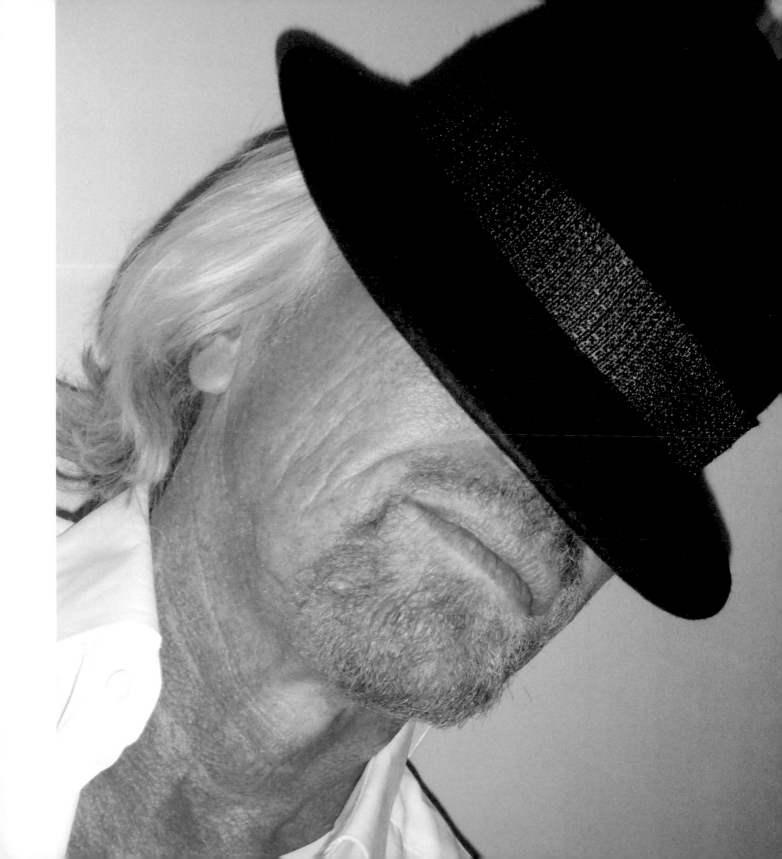

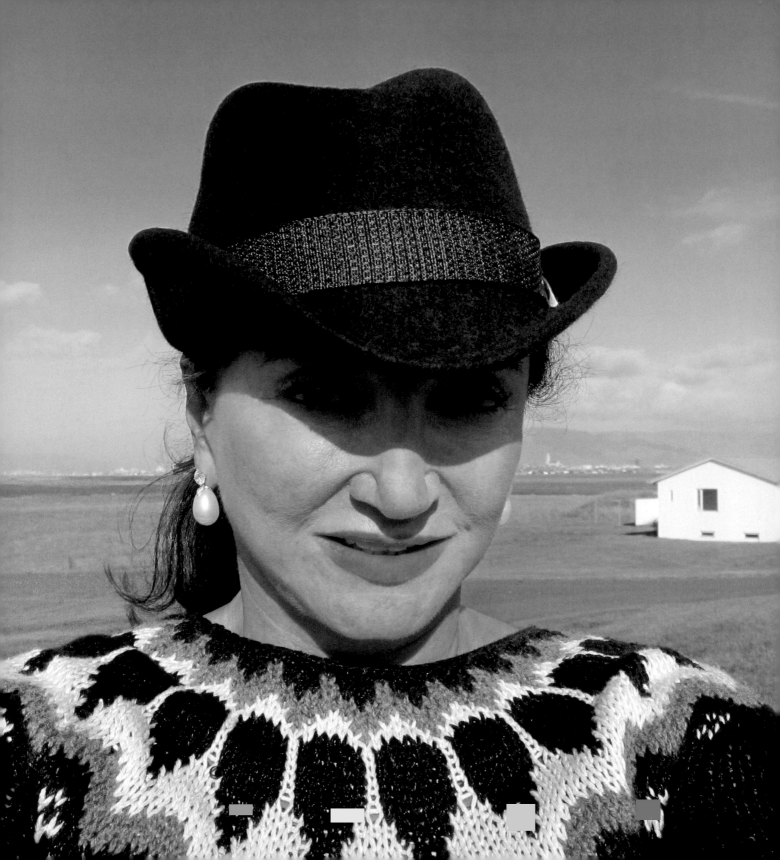

Wow! Iceland!

Dorrit Moussaieff

Treat everything on this earth with respect.

Ellen DeGeneres

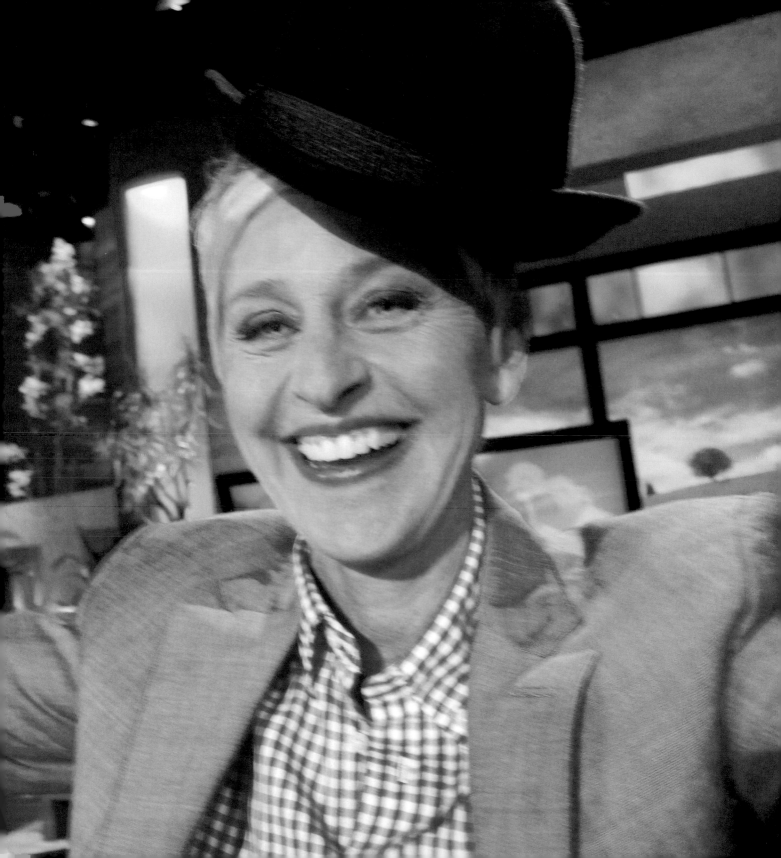

Silence is an energy; silence tells something; silence is a part of the world.

Marion Cotillard

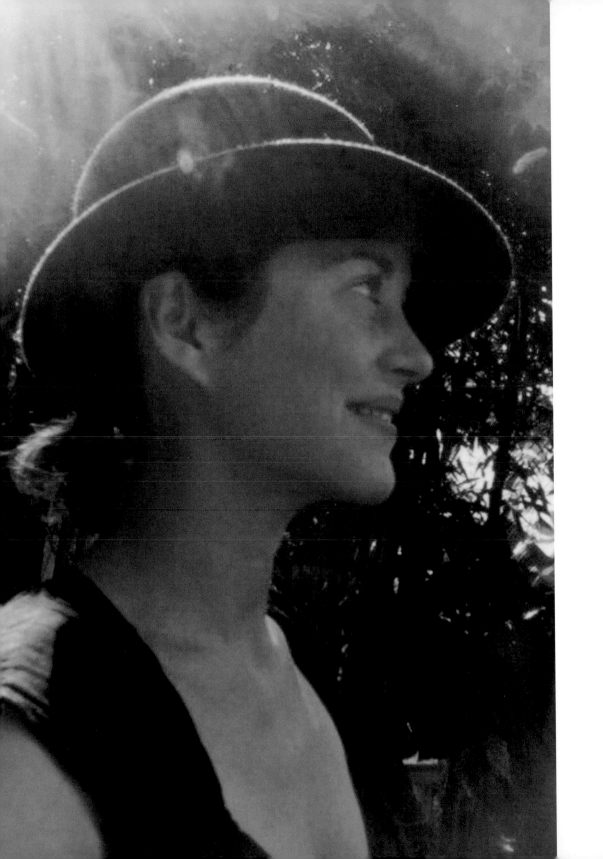

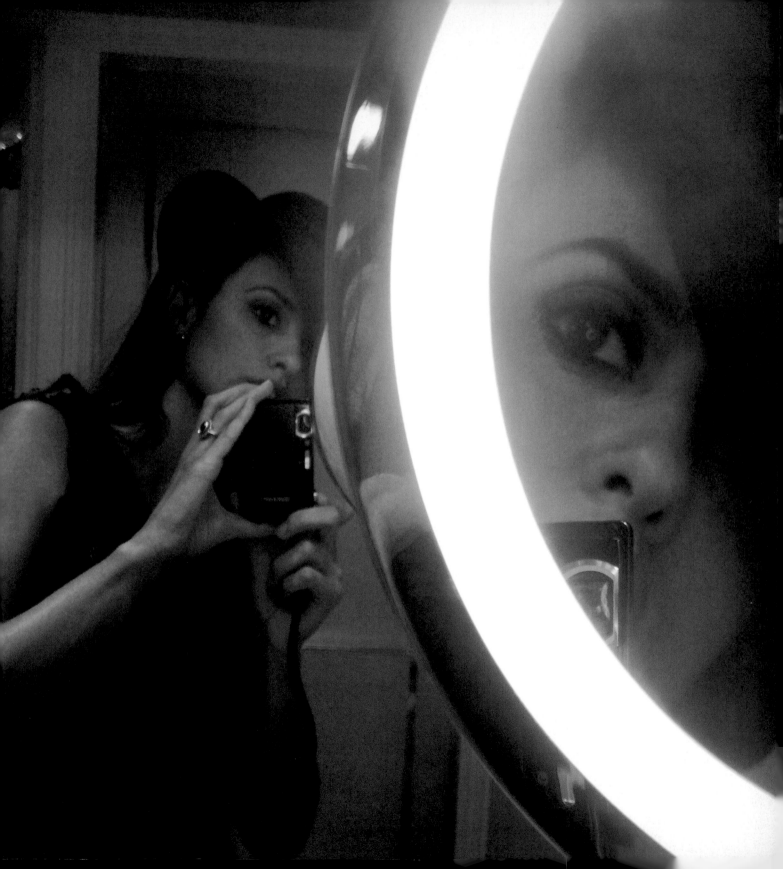

Thank you for listening.
Thank you for believing.
This is just the beginning . . .

Penelope Cruz

Mario Testino

Time means everything to me, it goes too quickly, it is too precious. As you get older, you see its value, you do not take it for granted. If I had an extra hour each day, I would just sit with it, I would try not to fill it with tomorrow's must dos. There is much I would want to change, and nothing I would change, as I believe everything happens for our greater good.

Gwyneth Paltrow

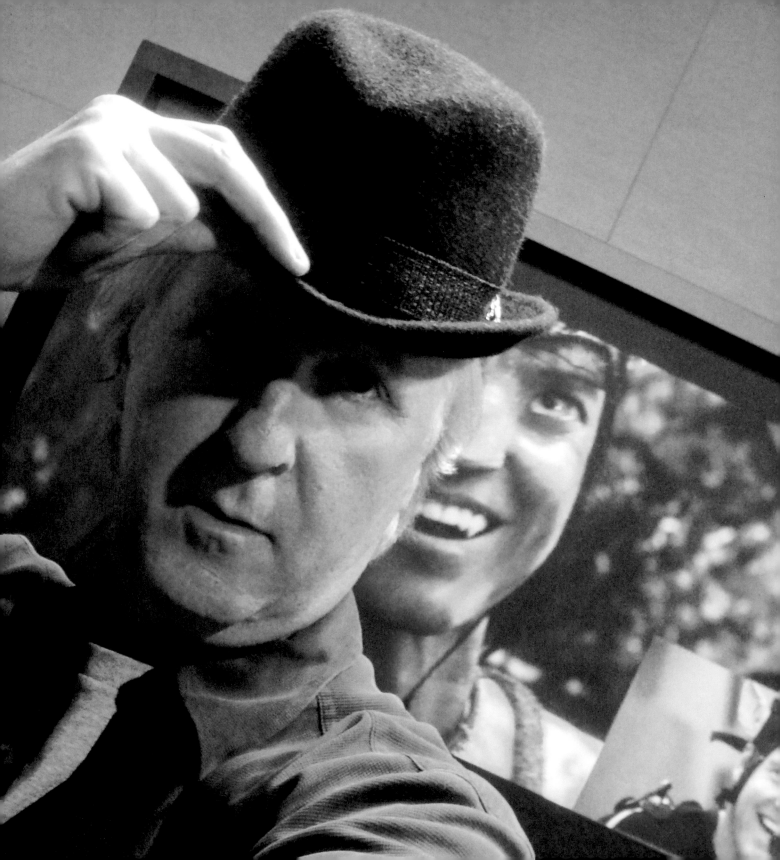

Sit down.
I have a lot of stories to tell you.

James Cameron

*I look like a right **** in this hat.*

Ricky Gervais

*It's not who we are
underneath but what
we do that defines us.*

Zac Efron

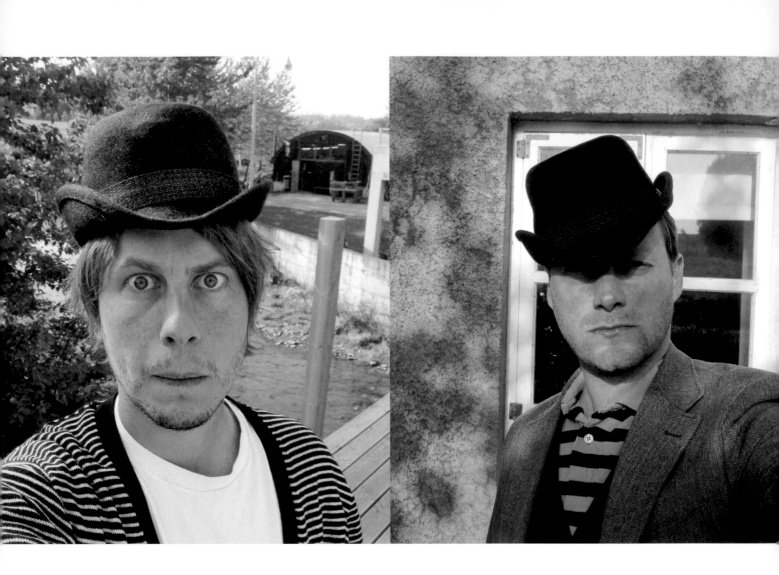

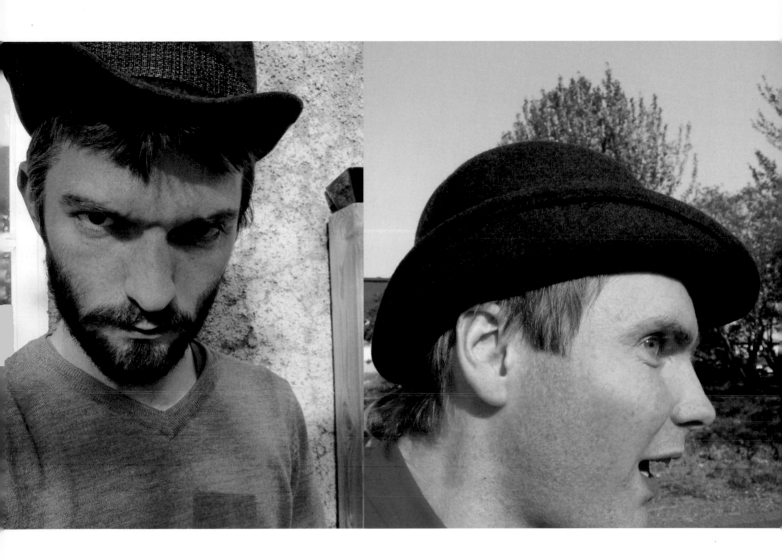

Let's sing!

Sigur Rós
Orri, Georg, Kjartan, Jon

Please . . . Let me swim in the ocean . . .
Every day!!!!!!!!

Hugh Jackman

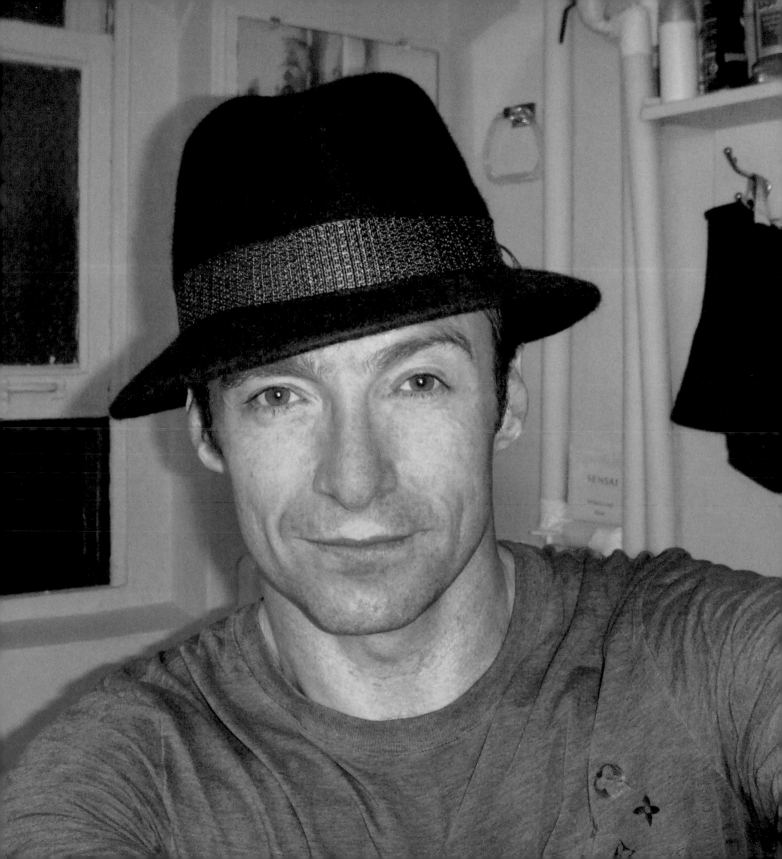

Tell me everything!

Naomi Watts

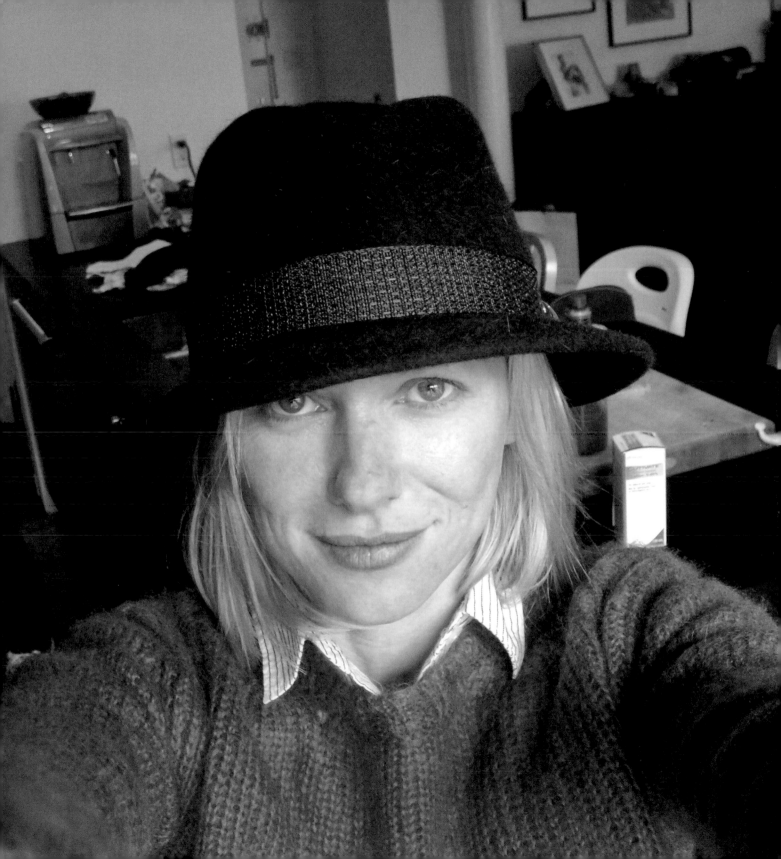

Wake up!!
It's 2012 already.

Chris Noth

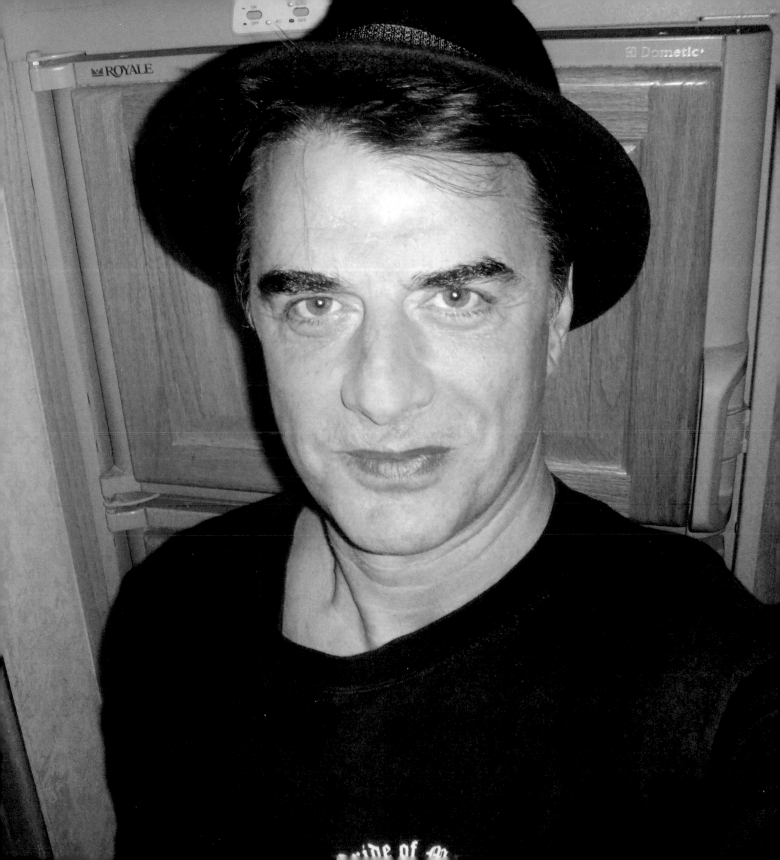

I don't need words to express who I am because I am beautiful, I am strong, and I speak through music.

Christina Aguilera

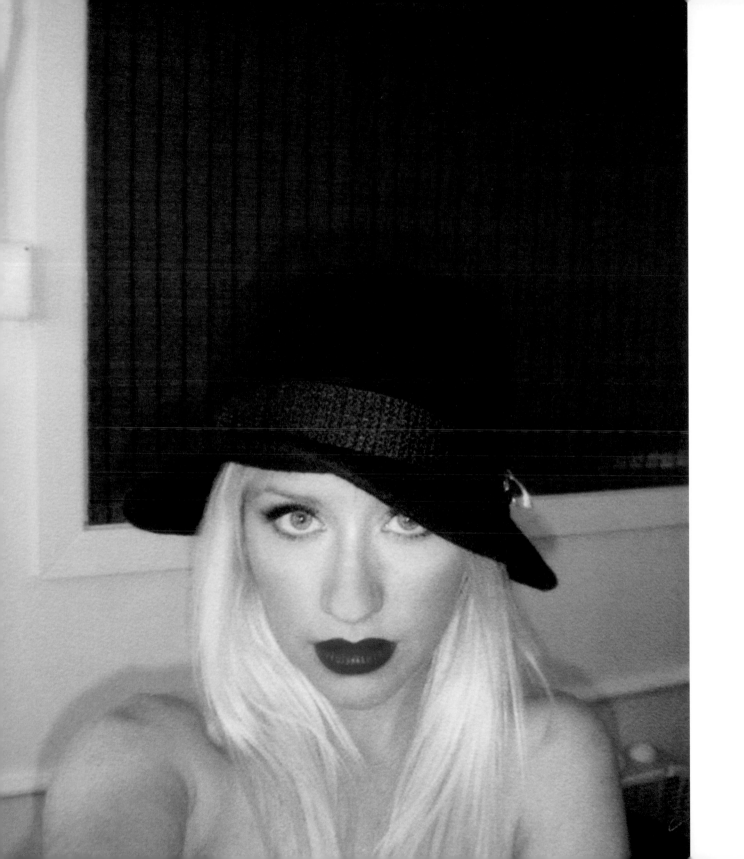

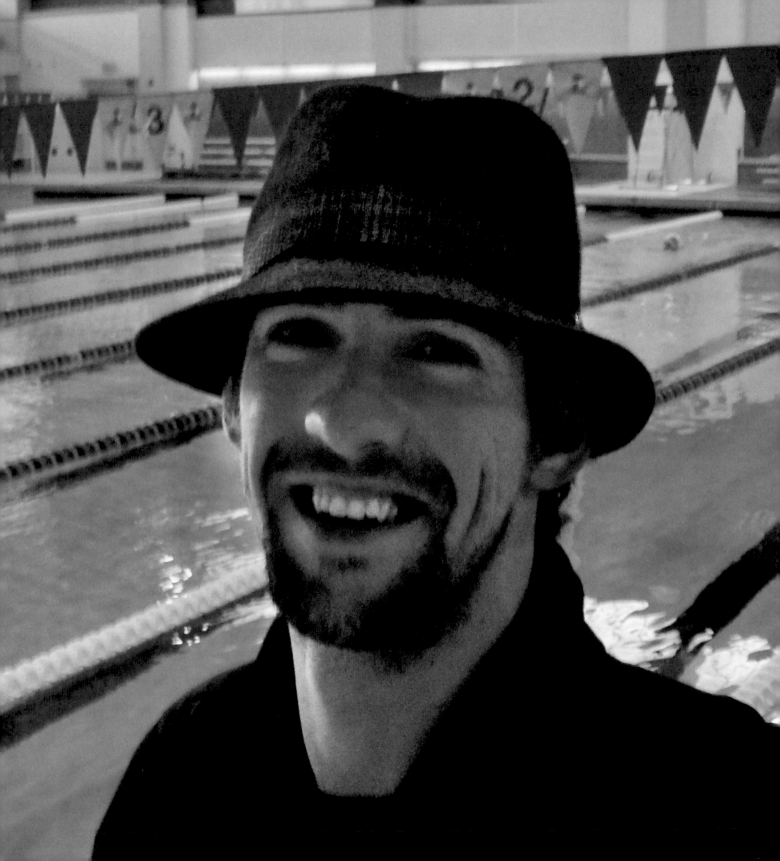

Dream, plan, reach.

Michael Phelps

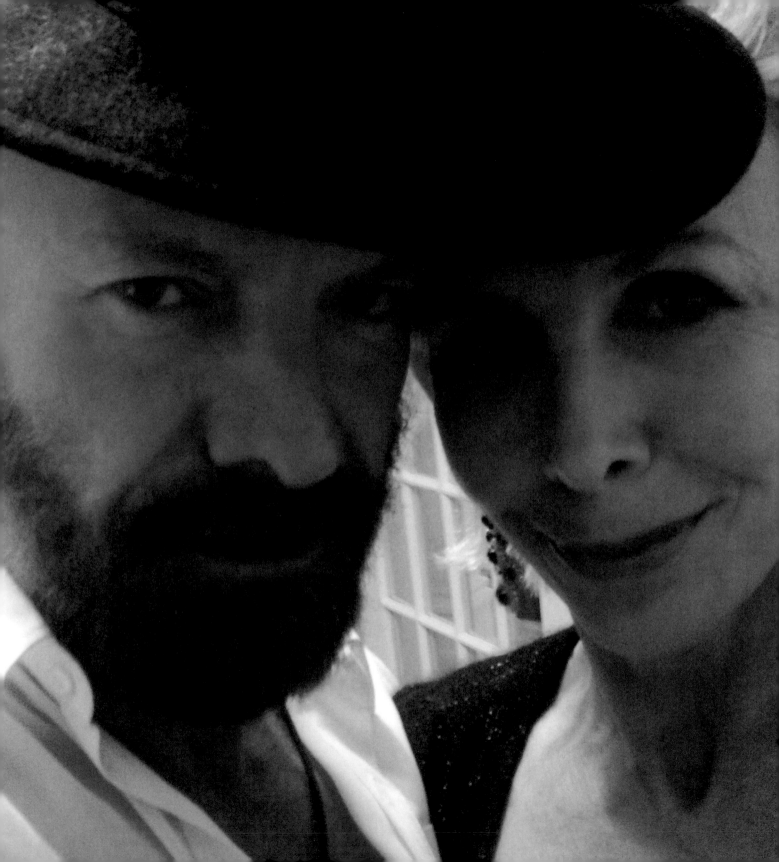

We want to share our special
gifts with the world.

Sting and Trudie Styler

I wish everybody would work together to get constructive things done in the world.

Temple Grandin

KELI'S WORDS

Still from *A Mother's Courage* (aka *The Sunshine Boy*), 2010.

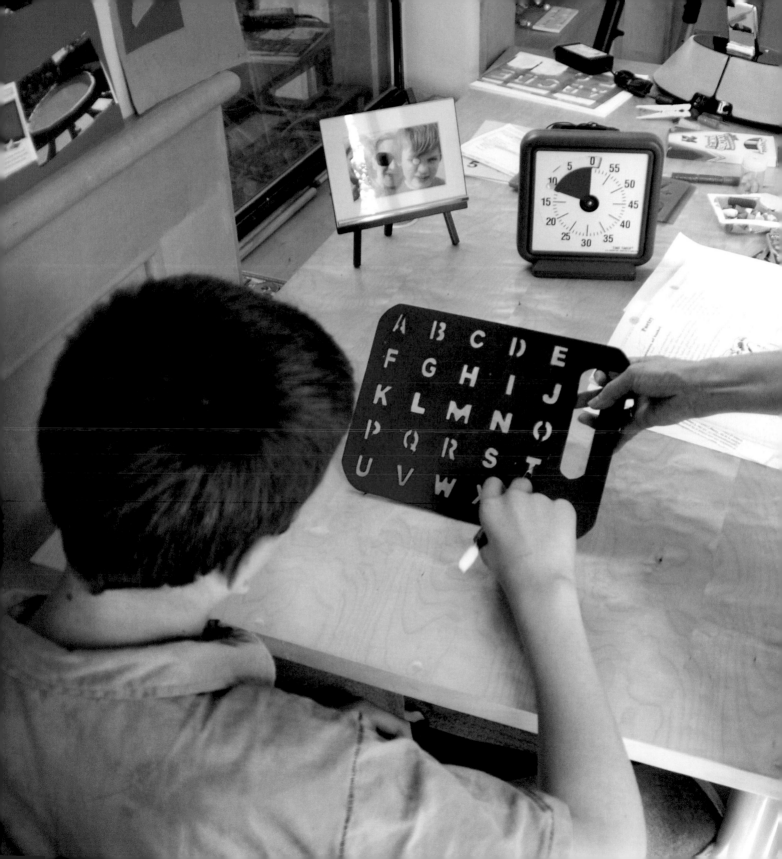

PLAYING

PLAYING IS ENJOYING ONE SELF
 IT IS DONE AFTER WORK IS OVER
PEOPLE PLAY TO MAKE FRIENDS
 IT IS HARD FOR ME TO PLAY
I CAN'T BE FAST LIKE OTHERS
 IT IS GOOD TO WATCH OTHERS PLAY
AND BE HAPPY FOR THEM
 I LIKE TO WATCH OTHERS

Still from *A Mother's Courage* (aka *The Sunshine Boy*), 2010.

MY FIRST COUNTRY SONG

MY EYES ARE NOT CRYING

THEY NEED TEARS TO CRY

I CAN SING WITH MY TEARS

PLAYING MY GUITAR

A ROAD TO OKLAHOMA

IN MY TRUCK CRYING ALONE

FAR FROM HOME

TORN AND SINGING WITH MY TEARS

Still from *A Mother's Courage* (aka *The Sunshine Boy*), 2010.

LIFE IS
A BIGGER PUZZLE

MOST CHILDREN LOOK LIKE THEIR PARENTS

 BUT MY BROTHERS LOOK SO DIFFERENT

I WANT TO LEARN ABOUT GENES

 LIFE IS ACTUALLY A PUZZLE

PEOPLE THINK ONLY AUTISM IS PUZZLE

 BUT LIFE IS BIGGER PUZZLE

Keli with brothers Unnar and Erik, Austin, Texas, 2010.

TO BE FREE

ART IS A WAY TO EXPRESS OUR THOUGHTS

WHAT IS LIFE WITHOUT ART?

THE ART THAT I HAVE IN MY HEAD

IT HAS A FIELD OF YELLOW KITES

AND NO STRINGS

IT IS CALLED TO BE FREE

I THINK I CAN START SOME ART CLUB

WITH MY FRIENDS

I AM THINKING MUSIC HAS TOO MANY RULES

IT IS HARD FOR ME

I CAN MAKE MY OWN RULES

WHEN IT COMES TO ART

GOD MADE AUTISTIC BOYS

GOD MADE AUTISTIC BOYS

 AUTISTIC BOYS LIKE TOYS

THEY HAVE NO CHOICE

 THEY HAVE NO VOICE

AUTISTIC BOYS ARE COOL

 OTHERS THINK THEY ARE FOOL

MOST BOYS HAVE SCHOOLS

 AUTISTIC BOYS LIKE SWIMMING POOLS

ICELAND

IN ANCIENT ICELAND THERE WAS A VOLCANO

IT WAS EXTINCT

PEOPLE CLIMBED ON IT ALL THE TIME

IT WAS CALLED KELI

ONE DAY A VIKING CAME AND MADE A HOME

FOR HIS PEOPLE BY BREAKING IT FLAT

HIS NAME WAS ICE

SINCE THEN ITS NAME BECAME ICELAND

PEOPLE

FIRST PEOPLE LIVED IN CAVES

NEXT THEY MADE HOUSES

FINALLY THEY LIVED IN MARS

AS THEY STUDIED SCIENCES

PEOPLE ARE NOT PENGUINS

THEY ARE NOT MACHINES

PEOPLE MAY HAVE SWINE FLU

IF THEY DON'T TAKE VACCINES

THE KING

THERE WAS A KING IN A BIG COUNTRY

HE GREW UP ON A TREE

BECAUSE HE WAS BROUGHT UP BY BIRDS

HE SANG LIKE BIRDS

AND HE TRIED TO TWEET LIKE THEM

ONE DAY HE WAS SPOTTED BY A MAN

HE WAS SINGING ON A BRANCH OF A TREE

HE WAS BROUGHT DOWN AND GIVEN EDUCATION

IT WAS HARD WORK FOR MANY YEARS

WHEN HE GREW BIG HE BECAME CLEVER MAN

AND GREAT SOLDIER

SLOWLY HE GREW TO BE A KING

END

Still from *A Mother's Courage* (aka *The Sunshine Boy*), 2010.

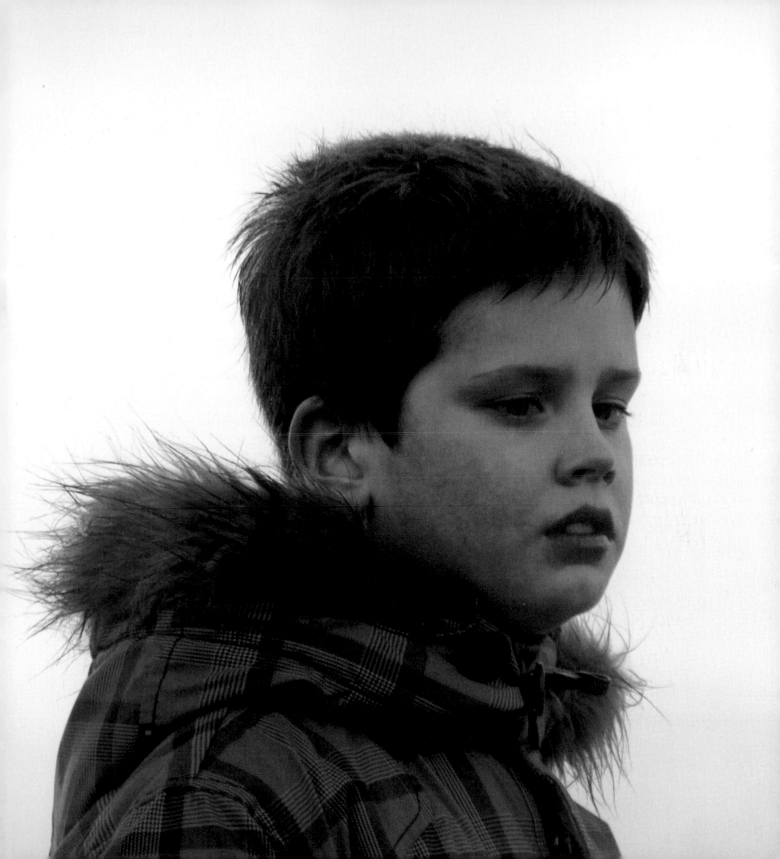

Our sincere thanks to all those who took part in this book. Thanks to their generousity, we have the precious opportunity to raise awareness for autism.

ACKNOWLEDGMENTS

First and foremost we'd like to thank:

Albertus Swanepoel, hat designer; Matt Allen; Brad Andrus; Celia Andrus; Jason Bell; Christine Blaauw; Julie Blumenthal; Vinny Cervello; Heather Chase; Tasmin Coleman; Errold Corbin; Dan DeRocco; Gudbjorg Edda Eggertsdottir; Sandy Figaro; Fridrik Thor Fridriksson; Carrie Gordon; Simon Green; Svafa Gronfeldt; Mindi Guttmann; Guy Harrington; John Hood; Ivar Pall Jonsson; Hrafnhildur F. Juliusdottir; Sara Keene; Erica Klein; Mark D. Koestler ; Mike Krentz; Wayne Mejia; Youcef Nabi; Kristin Olafsdottir; Brian Ott; Ivana Primorac; Hylda Queally; Vala T. Sigurdardottir; Paul Simnock; Joel Simon; Heidi Slan; David Souffan; Helayne O. Stoopack; Mary Wroblewski.